WONDERFUL WATERCOLORS
with Paul Brent

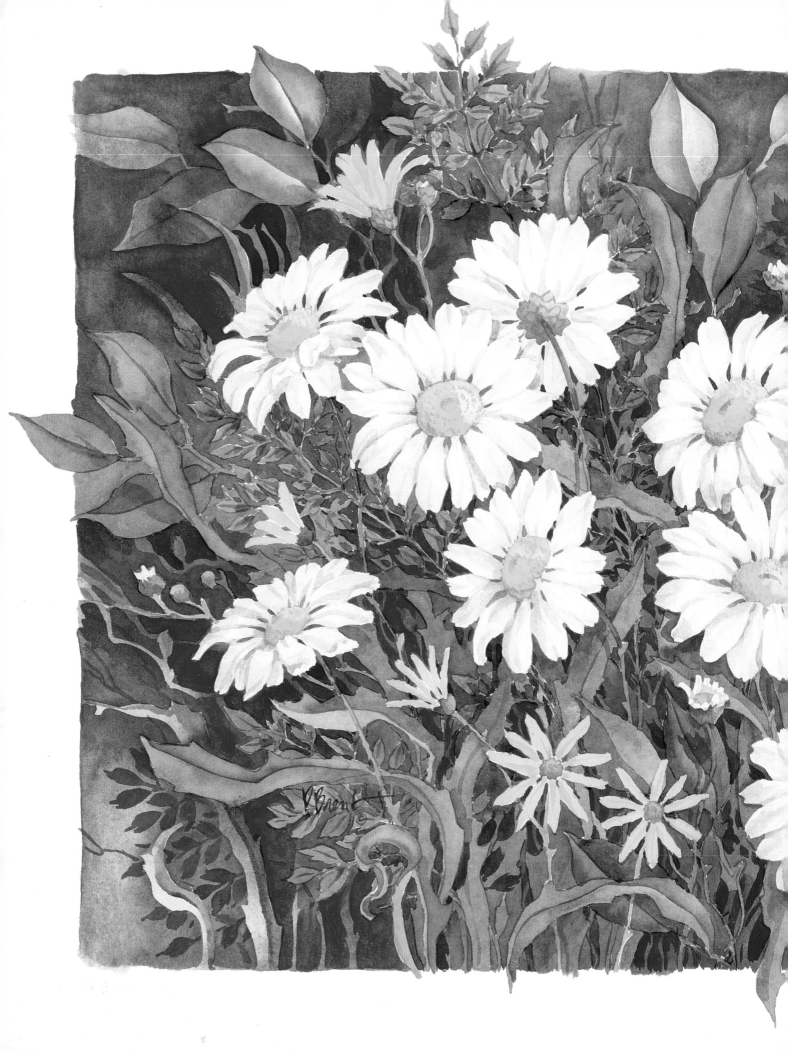

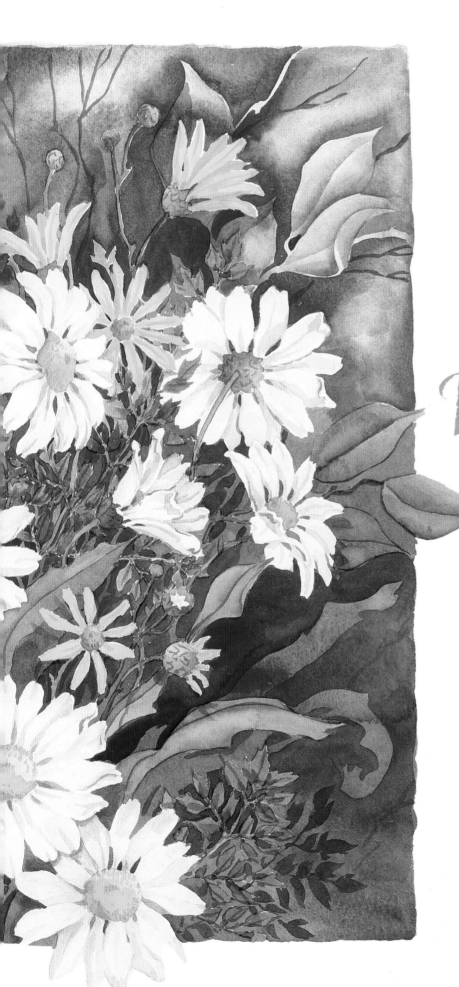

WONDERFUL
Watercolors
with *Paul Brent*

Great designs for your home!

North Light Books
Cincinnati, Ohio
www.artistsnetwork.com

ABOUT THE AUTHOR

Paul Brent was born in Oklahoma and introduced to art at an early age by his mother, an elementary school teacher. He received bachelor and master degrees from the University of California at Berkeley. After a four-year tour of duty with the Air Force, he settled in Panama City, Florida, with his wife, Lana Jane, and two sons, Jensen and Anders.

Paul is a signature member of the National, Florida and Southeast Watercolor Societies and the Society of Illustrators. He has exhibited in many prestigious exhibitions, taught college art courses and watercolor workshops and has work in notable collections worldwide. Paul illustrated the book *J. Rooker, Manatee* (Focus Publishing), and his work has been featured in *American Artist, Watercolor, Décor,* and *Art World News.*

Paul has sold over one million fine art prints since he began publishing them in 1986. His wife, Lana Jane, is president of the company that manages print publishing, licensing and a retail gallery of his work. Paul's artwork is licensed to numerous manufacturers of gift, stationery and home décor products. He has designed eight collections of wall coverings and fabric.

07 06 05 04 03 5 4 3 2 1

Library of Congress Cataloging in Publication Data
Brent, Paul.
 Wonderful watercolors with Paul Brent / Paul Brent.
 p. cm.
 Includes index.
 ISBN 1-58180-398-2 (pb. : alk. paper)
 1. Nature (Aesthetics) 2. Watercolor painting—Technique. I. Title.

ND2237 .B67 2001
571.42'24328—dc21

 00-068694
 CIP

Editor: Amanda Metcalf
Production Editor: Maureen Mahany Berger
Designer: Lisa Buchanan
Layout Artist: Matthew DeRhodes
Production Coordinator: Kristen Heller

Metric Conversion Chart

To convert	to	multiply by
Inches	Centimeters	2.54
Centimeters	Inches	0.4
Feet	Centimeters	30.5
Centimeters	Feet	0.03
Yards	Meters	0.9
Meters	Yards	1.1
Sq. Inches	Sq. Centimeters	6.45
Sq. Centimeters	Sq. Inches	0.16
Sq. Feet	Sq. Meters	0.09
Sq. Meters	Sq. Feet	10.8
Sq. Yards	Sq. Meters	0.8
Sq. Meters	Sq. Yards	1.2
Pounds	Kilograms	0.45
Kilograms	Pounds	2.2
Ounces	Grams	28.3
Grams	Ounces	0.035

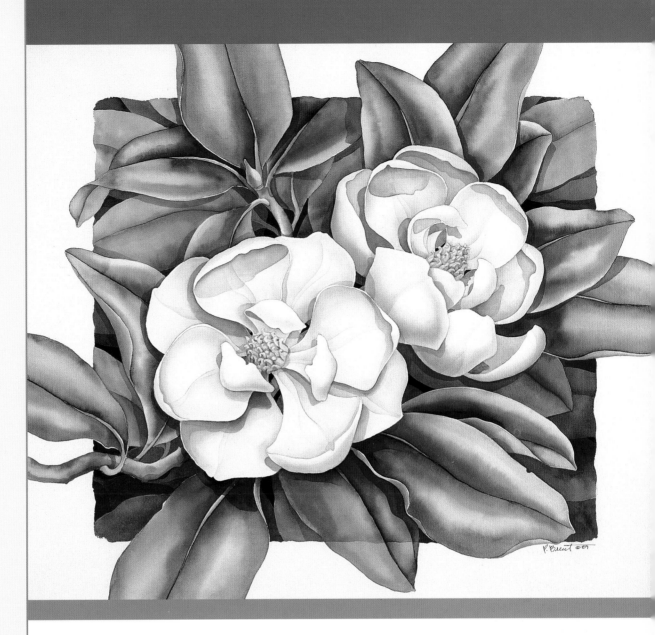

DEDICATION

This book is dedicated to my father and mother, Paul L. and Aledo Brent, who encouraged me to explore the world visually. They gave me the gift of education and personally exemplified the importance of lifelong learning as the key to a meaningful and satisfying life.

ACKNOWLEDGMENTS

Thanks go to my wife, Lana Jane, without whom my career and this book would not have been possible. Special thanks are also due to my dedicated staff, who assisted in the many details necessary to complete this book.

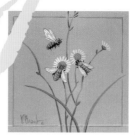
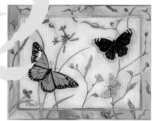
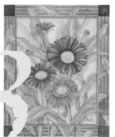
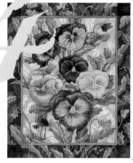
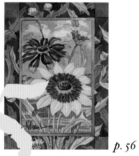
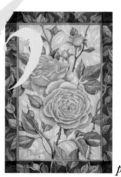
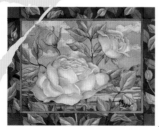

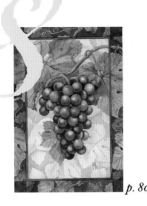

TABLE OF CONTENTS

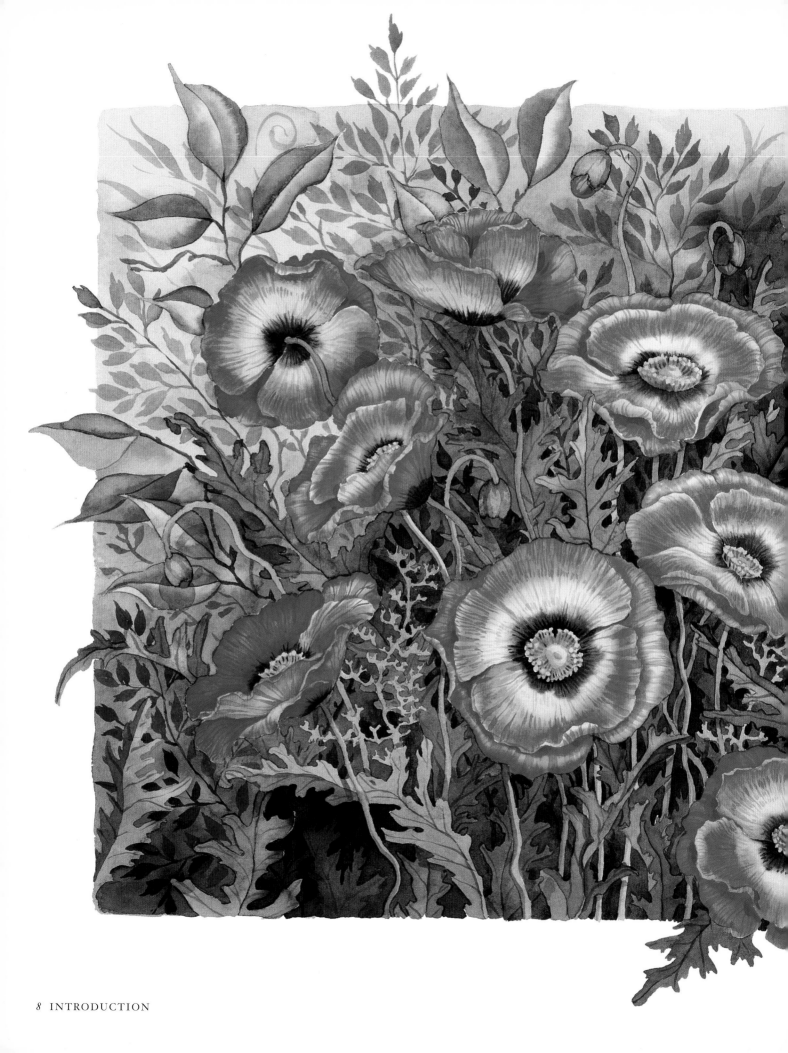

Introduction

This book is all about enjoying watercolor. Every artist can learn to manage this medium. Watercolor has a reputation for being difficult, but I'll show you how to use its rebelliousness to your advantage. With a few tips and some practice, watercolor can be a delight to all artists from beginners to advanced painters. You'll delve into practice paintings to build skills and to rid yourself of the fears too many have of this wonderful medium.

The Beginning

A good painting begins with a good drawing. It's worth putting in the time at the start of a project to create a balanced composition and a well thought-out plan. This is especially true when using transparent watercolors, in which each layer is visible beneath the others. That's not to say that painting with watercolors is difficult. With planning, the results can be as easy to achieve, and pleasing, as with any other medium.

Persistence and the Creative Spirit

Many people have asked me how long it takes to complete a watercolor painting. I could tell you the exact number of hours it took to paint each painting in this book, but the real answer also includes the thirty plus years I've been painting. Truly, each painting is the product of all your experience put together. Watercolor flows easily, so it covers the surface and dries quickly—which is why I enjoy painting with it. Once you learn the technique of laying down watercolor, your creative spirit can take free rein.

This Book

This book will help you build technical skills while creating attractive artwork. I have built my own skills through classes, books, workshops, practice and experimentation. Throughout this book you'll learn from my experiences and create some of your own. Each demonstration begins with a few mini demonstrations to show you how to paint individual elements of the painting. Practice these to get the color and techniques down before moving on to the painting. You'll find that working out problems before you begin a watercolor painting really helps and can keep you from becoming too frustrated. As an additional help, you'll also find line drawings for each of the thirteen paintings on page 16.

Basic Materials

You don't need much to paint with watercolors, but it does help to have everything you need at hand before you start painting.

Paper

Watercolor paper comes in three basic finishes: hot-press, cold-press and rough. Hot-press paper is very smooth, and paint tends to puddle on its surface. Cold-press paper has a moderate "tooth," or roughness. The tooth holds the pigment in place better than hot-press paper but still provides a fairly smooth surface. Rough paper has the most dimension to its surface and creates a strong textural backdrop for paintings.

Watercolor paper also comes in a variety of weights. The most popular weights are 140-lb. (300gsm) and 300-lb. (640gsm). Large pieces of 140-lb. (300gsm) paper can warp because paper expands when wet. To prevent warping, wet the paper and tape it to a board. Then let it dry so it stretches as it dries. Then when you wet the paper during the painting process, it won't buckle as much. This process, called stretching, can be time-consuming, so I just prefer to use 300-lb. (640gsm) paper. The heavier weight makes it less likely to warp.

I usually use Saunders Waterford 300-lb. (640gsm) cold-press watercolor paper. It's made in England but readily available from most art supply catalogs. I use a Strathmore cold-press 140-lb. (300gsm) watercolor pad for sketching on site. Arches also makes quality watercolor paper.

Paint

Winsor & Newton and Grumbacher both produce quality watercolor paints. Tube watercolors, instead of cakes or pans of dry pigment, give the most vibrant effects. Tube paint is also easier on your brushes. You don't have to use your brushes to lift your paint like you do when using cakes. You can apply tube paint to a dry surface for opaque color or add it to a wet area for vibrant bleeds. I encourage any new artist to experiment with different pigments to find what works best for your art. You'll need a full range of colors. Following is a list of the Winsor & Newton and Grumbacher colors I used for the paintings in this book:

Burnt Umber
Cadmium Yellow Deep
Cadmium Yellow Light
Cerulean Blue
Grumbacher or Winsor Red
Indian or Venetian Red
Mauve
Payne's Gray
Permanent Green Light
Permanent Sap Green

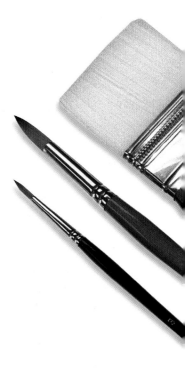

MY BRUSHES
I generally use a 2-inch (51mm) flat brush, a no. 10 round brush and a no. 3 round brush.

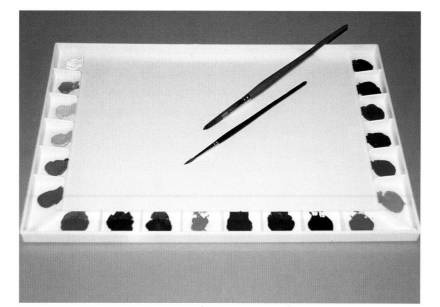

MY PAINTS AND PALETTE
I use a John Pike plastic palette with paint wells and arrange my paints as shown on the left.

Raw Umber
Thalo or Winsor Blue
Thalo or Winsor Crimson
Thalo or Winsor Green
Thalo or Winsor Yellow Green
Ultramarine Blue
Vermilion
Yellow Ochre

For white, I use Designer's Gouache Permanent White because it is a very opaque white for highlights. It also can be thinned to make washes over watercolor.

Palette

I use a John Pike plastic palette that is 15" x 10 1/2" (38cm x 27cm). It's light, scrubbable, great for traveling and the cover keeps paint moist.

Brushes

I can achieve every effect I want with a very limited number of brushes. I use a Robert Simmons 2-inch (12mm) flat synthetic sable brush, a Pro Arte Prolene Plus Series 007 no. 10 round synthetic sable brush and a Percy Baker Rekab Series 3 no. 3 round genuine red kolinsky sable brush. Synthetic bristles work well when new, but their points wear down quickly, especially on smaller brushes. Genuine sables keep their points much longer but are

more expensive. If cared for, they are well worth the price in the long run.

Tracing Paper

I keep rolls of 14-inch (36cm) and 24-inch (61cm) white tracing paper on hand for developing my drawings. They are both sold in rolls at drafting and office supply stores.

Light Box

You don't need a light box for these demonstrations, but I find it a great help for transferring my drawings from tracing paper onto watercolor paper.

Lighting

I paint in north daylight with supplemental fluorescent lights. Cool, white fluorescent light is the most compatible with daylight. If colors look good in this light, they'll look good in any other light, too.

Other Supplies

You'll also need facial tissues; a Pentel retractable, white, non-abrasive eraser; drafting tape; a felt-tip pen; cotton swabs and HB and 2H lead pencils for sketching on the tracing paper.

MY DRAWING TOOLS

I like to use a mechanical pencil with 2H lead and a retractable eraser. For tracing, I also use a felt-tip pen.

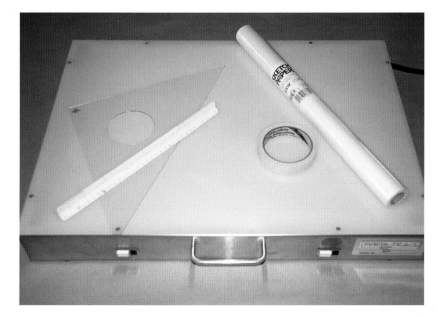

OTHER SUPPLIES

I do my original drawing on tracing paper and then transfer it to watercolor paper, using a light box as backlight. I use a triangle or another straight edge to draw straight lines and a scale to help with proportions. I also like to frame my drawings with drafting tape before I start painting.

Basic Techniques

The key to getting watercolors to do what you want lies more in the preplanning stages than in actually applying paint to paper. You have to prepare the paper and plan the drawing and color scheme. If you hold the brush correctly and paint small areas at a time, watercolors can remain in your control.

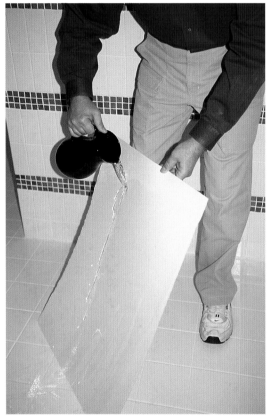

WASHING PAPER
I wash my watercolor paper before painting on it so it will better absorb paint and water. Gently pour water over the front surface of the paper while holding the paper at a slight angle from vertical. Use as little water as possible to cover the entire sheet. Hold the paper until it has stopped dripping, then lay it flat to dry.

Preparing the Paper
Many watercolor papers have a strong sizing, a starch-like coating, on the surface of the paper. The sizing prevents the paper from absorbing moisture from the paint. It also can cause paint to bubble up a bit at the edge of a stroke. The result can be delightful in some cases, but I prefer to reduce the effect of the sizing by washing every sheet of paper so each stroke will have a clean edge. A light wash of clear water removes some of the sizing and allows the watercolor to better adhere to the paper. You'll find it much easier to paint on a surface that has been washed first.

Drawing
Watercolor paper is very sensitive. Erasing and re-drawing causes the fibers of the paper to trap paint, leaving a muddy look. I draw and rework my drawings with an HB pencil on tracing paper, outline the drawings with a felt-tip pen and then trace them onto watercolor paper using a light box for backlighting. Use a 2H pencil and don't bear down when tracing. This will leave a faint line that you can erase easily with very little damage to the paper. Unless you want pencil lines to appear in the final painting, erase lines you don't need after the area dries thoroughly, preferably after your first wash of color.

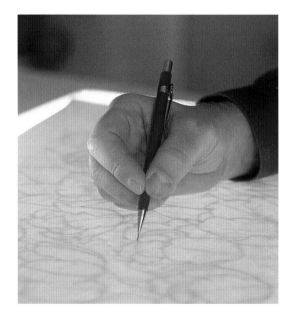

TRACING
Once I'm satisfied with the drawing I've done on tracing paper, I outline it with a felt-tip pen. Then I place the tracing paper on a light box and the watercolor paper over the tracing paper. The backlight and dark lines from the felt-tip pen make it easy to trace with a 2H pencil.

Holding the Brush

Everyone wants to know how to control watercolors. The brush delivers paint to the paper differently depending on the way you hold it. You can't control watercolors; but once you understand the different ways to hold a brush, you'll be able to predict how they'll behave.

Grip your brush lightly and hold it at a lesser angle than you would hold a pencil. Begin your stroke by sliding the bristles along the surface (away from the bristles and) toward your arm. Move your arm rather that your wrist. You'll get a smoother stroke, especially when covering larger areas.

For details, rest your wrist on a dry area of the paper and use your brush more like a pencil. Paint fine, tapered strokes for elements like grass, pulling away from the origin point of the stroke. You'll have more freedom and control with a stroke that is first anchored on the ground line and then pulled away from that point in a fairly quick motion.

Painting in Segments

Many artists try to paint too large an area at one time. Think of your painting as a puzzle, and paint the pieces. By breaking shapes into smaller ones, you can better control where the paint goes. Make more specific decisions about color and value; if necessary, even remove the color before the paint has a chance to dry.

For backgrounds and large shapes with no break in color, brush clear water to make a border around a smaller area. While the water is still wet, paint the area between the wet spaces. Allow this area to dry, then begin the next section with clear water again. Blend the overlapping areas and pat the edges of the wet areas with a tissue to prevent a hard edge from forming.

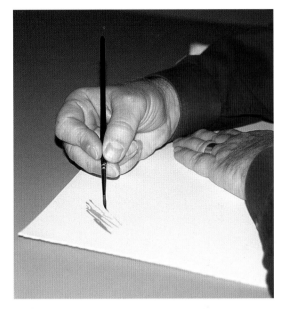

HOLDING THE BRUSH

Hold the brush at an angle closer to the paper than you would hold a pencil and pull the stroke away from the bristles in the direction of the handle.

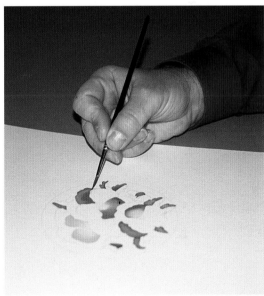

PAINTING IN SEGMENTS

Don't paint too large of an area at once. You'll have more control over color and value choice if you paint smaller areas. Don't paint an area next to another area of wet paint unless you want the colors to bleed together. Wait for the adjoining area to dry before painting the one next to it.

Basic Techniques, *continued*

Background Wash

I sometimes begin a painting with a background wash to tone the painting. First wet the paper evenly with clear water. For a large painting, pour the water on as described in the section on preparing paper. While the paper is still wet, begin painting at the top of the sheet with a 2-inch (51mm) flat brush.

Cover the sheet with overlapping horizontal strokes. Load your brush again and cover the sheet with vertical strokes. Then, without loading any more paint onto your brush, smooth out the wash by alternating layers of horizontal and vertical brushstrokes. Don't repeat too many times, though, you'll remove too much of the sizing and the following layers of paint will become muddy. Work quickly and keep the entire sheet damp during the process. To save time, premix the paint before you begin so the paint on the paper doesn't start to dry while you're mixing.

Color

I work with a bright palette of colors for maximum brilliance. My color philosophy is quite simple: to lighten a color, add water; to brighten an area, add another layer of paint; to achieve a more muted color, use a neutral. For example, add Indian Red to Mauve, Payne's Gray to Sap Green or Yellow Ochre to Cadmium Yellow. Adding a neutral color instead of a complementary color allows you to modify the colors delicately. Adding a complementary color to neutralize a shade may cause an unwanted color shift.

I also use Payne's Gray for my black areas. Payne's Gray has a touch of blue and works better than Ivory Black does with my bright palette. I use Grumbacher's Cerulean Blue with a touch of Ultramarine Blue for skies. I use Permanent Sap Green for leaves and vegetation, modifying it with other colors from my palette to create a range of greens.

The single greatest tool for judging color is a test strip from the same paper you're painting on. I test almost every stroke before adding it to the painting to best judge the color and amount of paint I should load on the brush.

Beginning the Painting

Plan each painting before you begin. On a test strip of paper, lay out the basic colors of your painting as well as some variations of these colors. Do a quick thumbnail sketch to help establish color and values.

Begin boldly by painting the light midtone areas. Also apply midtones to areas that will be darker. You'll make these areas darker later. Then block in the shaded areas with a mixture of Cerulean Blue and Mauve to give form to all of the shapes. Next layer color over the background and foreground until all midtone areas are covered. Leave the light areas white. Now your painting has structure.

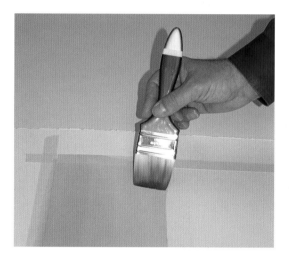

APPLYING A BACKGROUND WASH

Wet your watercolor paper and then cover it with paint, using slightly overlapping horizontal strokes. Start at the top and work your way down. Then go over these strokes with slightly overlapping vertical strokes, moving from left to right. Then smooth the wash out by going over the strokes without adding anymore paint to the brush.

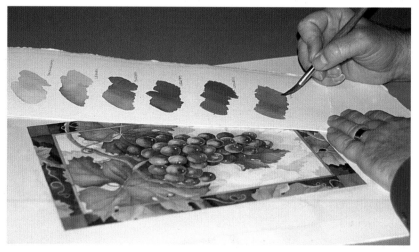

TESTING COLORS

Apply each color you want to use, both from the tube and mixtures, to a test strip of paper. Examine the color scheme and adjust the mixtures until you're satisfied. This method will make the actual painting process go more smoothly.

To think of this process another way, apply the background first, leaving the foreground in silhouette. Then add your light colors and finally your darks. Remember to allow each area to dry before painting over or next to it.

Laying Down Color

One of the most exciting things about watercolor is that it can flow freely and appear wet or fresh even when it's dry. To create color like this, lay down clear water or a pale wash of color over the area you're going to paint. Lightly stroke intense colors of paint into the wet area; the paint will begin to spread in tiny fingers of color. You also can drop tiny drops of color into the wet area. This method allows more control over how the color spreads, and you can use it to create interesting texture.

Overpainting

Often, an area of your painting may look unappealing because it has an unattractive dry line or seems muddy. Just as in other mediums, simply apply another layer of paint. Even a pale wash of the same color can work miracles. You also can paint a shadow pattern or a texture over the area to disguise the offending spot.

Removing Color

Once you've applied pigment to the paper, you can remove it several ways. While the paint is still wet, blot the area with a clean tissue. Much of the pigment will lift off. You can also lift wet paint with a dry, clean brush to soak up water and paint.

After paint has dried, lifting color is considerably more difficult. Some pigments, such as Cerulean Blue and Indian Red, respond fairly well to a light scrubbing with clear water and a soft brush. Use a more vigorous action with a stiff brush to remove other colors, such as Thalo Blue and Thalo Green. After scrubbing, rinse the area with clear water and a brush. Then press firmly with a tissue to lift the loosened pigment.

You can rub away some color with a white eraser. You can also use a craft knife to lift small highlights or remove splatters to get back to the white of the paper. Carefully scratch over the area, disturbing only the flecks of pigment you want to remove. Then go over this area with a white eraser to smooth the paper.

Don't remove paint that has already dried until the final, touch-up stage. These techniques with an eraser or a knife can destroy the surface of the paper, making it difficult to paint over. The paint will sink into the body of the paper on the changed area rather than sitting on the surface like the paint on the surrounding areas.

LIFTING PAINT WITH A TISSUE

Lightly blot areas of wet paint with a tissue to remove paint.

LIFTING PAINT WITH A BRUSH

A clean, dry brush, sometimes referred to as a thirsty brush, helps lift smaller areas of wet paint whether you want to correct a mistake, create a highlight or lift extra paint from an area.

Line Drawings

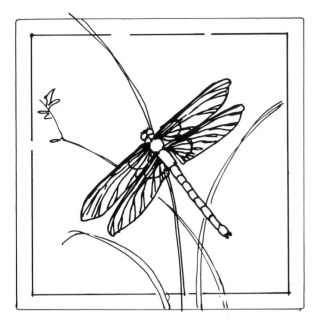

Garden Dragonfly

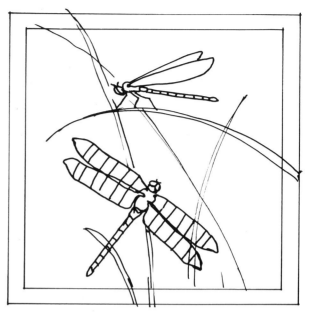

Garden Damselfly and Dragonfly

Garden Bumblebee

Garden Honeybees

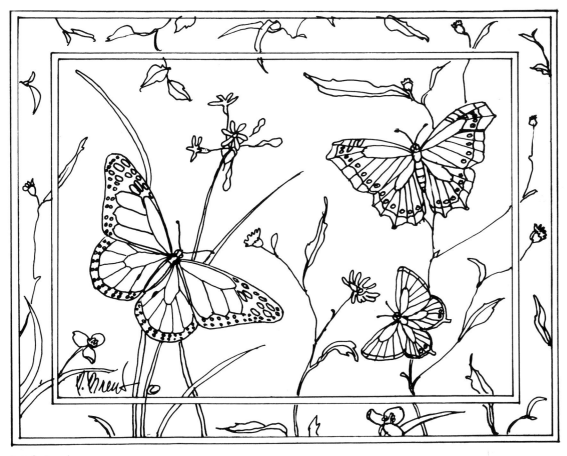

Butterfly Sampler

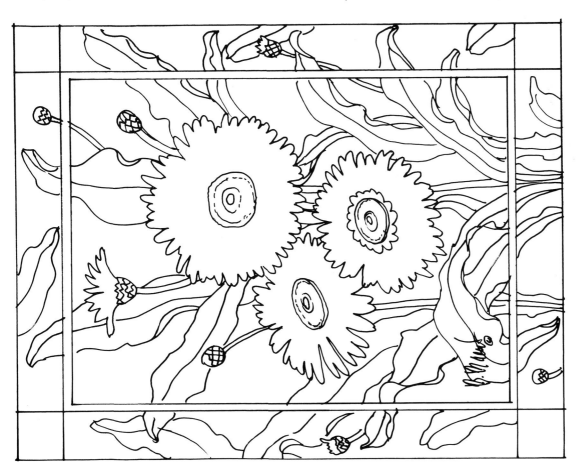

Gerbera Daisies

Line Drawings, *continued*

Pansy Family

Gloriosa Daisies

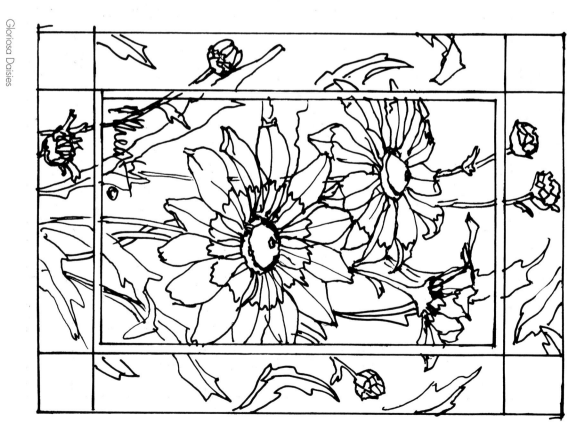

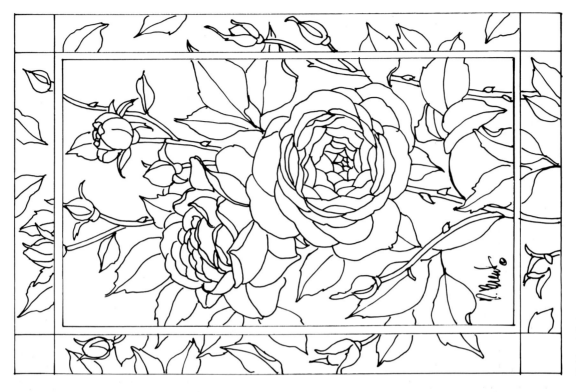

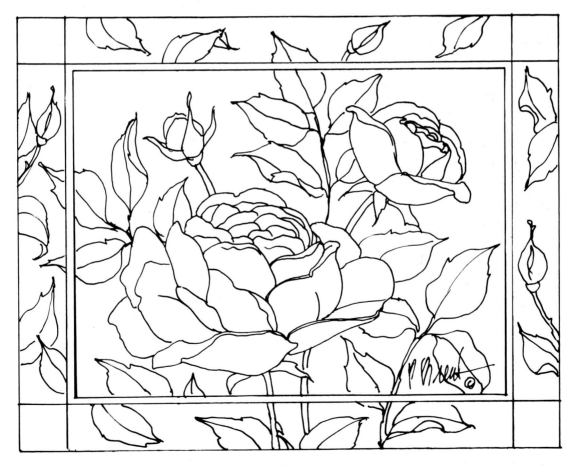

English Tea Roses

Line Drawings, *continued*

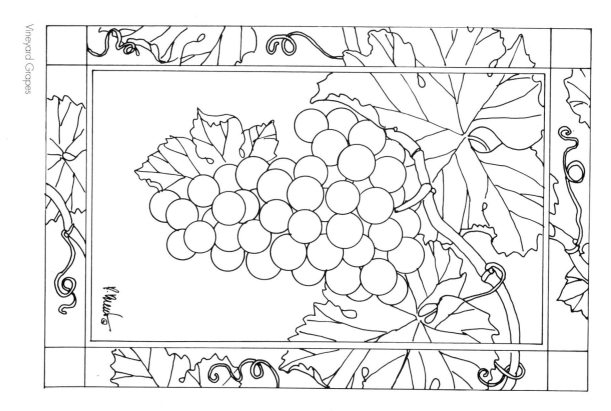

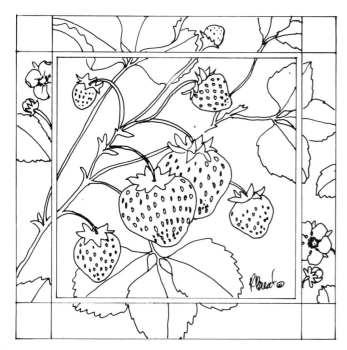

Scarlet Strawberries

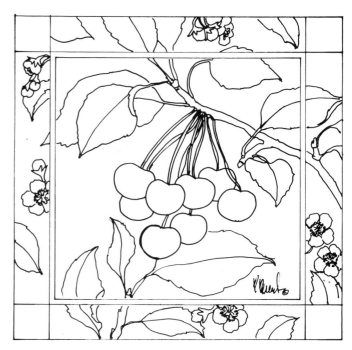

Florence Cherries

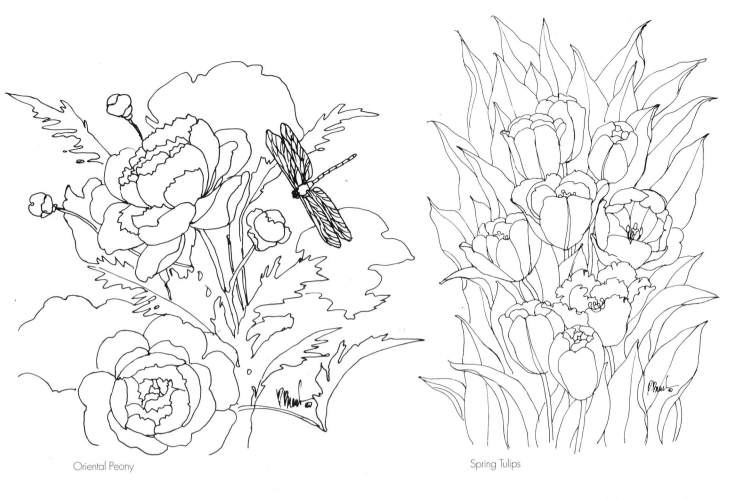

Oriental Peony

Spring Tulips

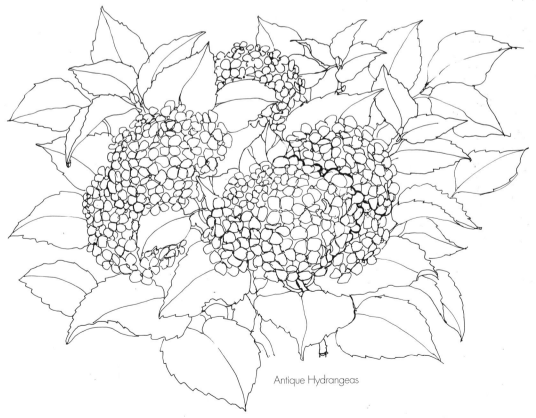

Antique Hydrangeas

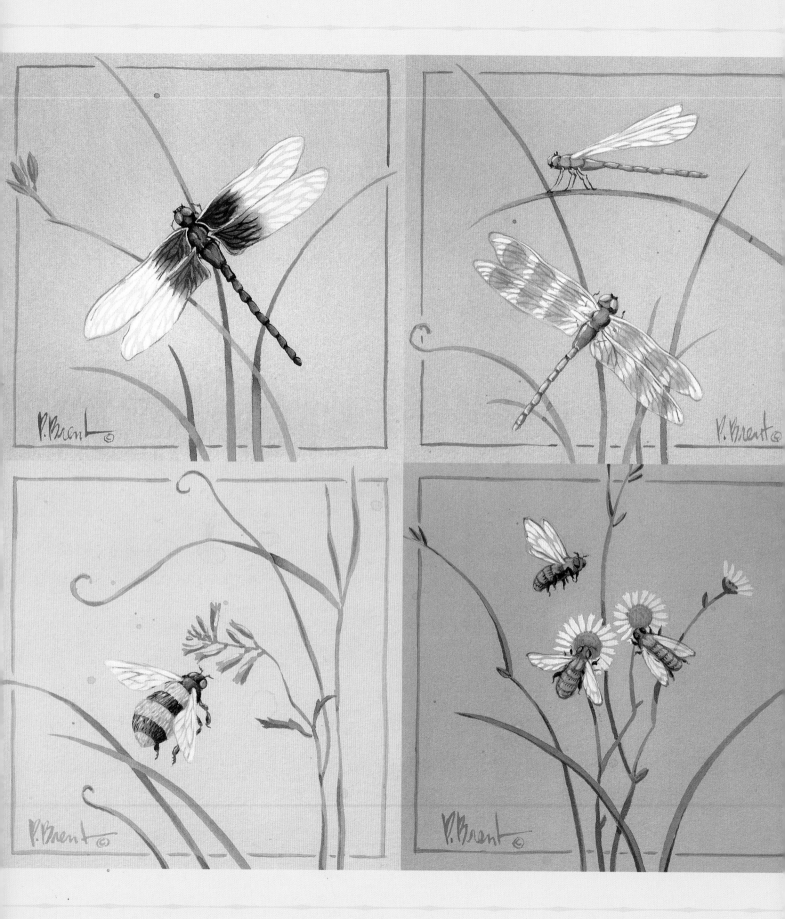

Garden Insect Tiles

◆ *I've admired insects and their intricate structures since I was very young. I still have my first insect collection, which won first place in the Caddo County Fair in Oklahoma. I chose to paint the insects in this project on toned paper to provide a subtle background for the patterns on the wings and bodies of the insects. I loosely suggested the foliage in quick, open strokes, much like Japanese brushwork. Using both semi-transparent and opaque white gouache creates the illusion of delicate wings that are both reflective and transparent.*

MATERIALS LIST

BRUSHES
no. 3 round
2-inch (51mm) flat

PALETTE
Cadmium Yellow Deep
Cadmium Yellow Light
Cerulean Blue
Indian or Venetian Red
Mauve
Payne's Gray
Permanent Sap Green
Vermilion
Yellow Ochre

SURFACE
12" x 12" (30cm x 30cm)
 300-lb. (640gsm) cold-press
 watercolor paper

OTHER
black felt-tip pen
drafting tape
eraser
facial tissue
2H lead pencil
Winsor & Newton Permanent
 . White Designer's Gouache

Practice Painting Dragonflies and *Damselflies*

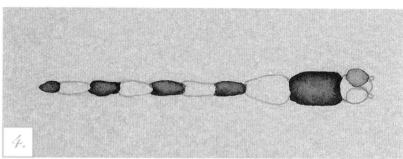

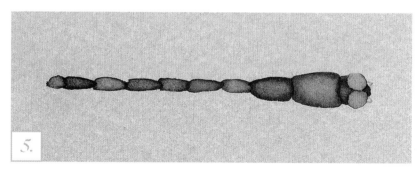

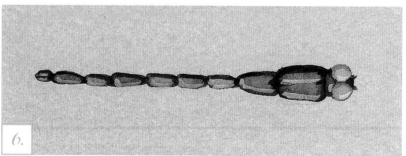

1. UNDERPAINT WING

Paint the basic shape of each wing with a semi-opaque wash of Permanent White gouache. Allow the wash to dry.

2. ADD SPOT

Add the colored spot near the end of each wing closest to the insect's body with Payne's Gray. While the paint is still wet, brush some clear water around the outer edges of the spot, staying within the borders of the wing. Let the Payne's Gray run into the water so the paint grays a bit toward the edges of the spot. Blot the edges of the clear water with a tissue to prevent a hard edge from forming.

3. ADD DETAILS

Add white reflections to the wings with Permanent White gouache. Add the line work with Payne's Gray.

4. BEGIN BODY SEGMENTS

Paint every other segment with a mixture of Payne's Gray and a little Indian or Venetian Red. After you finish painting each segment, drop just a little clear water into the center. Then lift excess water with a dry brush. Allow the segments to dry. The lighter shade in the middle of each segment makes the insect look more rounded and three-dimensional. It also indicates movement, as if the sunlight were catching the segments at different angles. Paint one eye the same way with Permanent Sap Green.

5. PAINT REMAINING SEGMENTS

When the first segments and eye have dried, paint the rest the same way. Don't paint an area until adjoining areas have dried.

6. ADD DETAILS

Add shadows with the original color and highlights with Permanent White gouache.

✦ DEMO ✦
Practice Painting Bumblebees and Honeybees

1. UNDERPAINT BUMBLEBEE BODIES

Paint the black stripes with Payne's Gray and the yellow stripes with a mixture of Cadmium Yellow Deep and Yellow Ochre. Also paint the head and eyes with Payne's Gray. Allow the washes to dry.

2. PAINT SHADOWS

Paint the shaded areas with darker values of each color to give the bee dimension.

3. ADD DETAILS

Paint the lightest hairs and highlights with strokes of Permanent White gouache and Cadmium Yellow Light. Paint the darker hairs on the yellow bands with Yellow Ochre. Paint the lightest hairs on the black bands with a mixture of Permanent White gouache and Payne's Gray. Paint the darker hairs on these areas with Payne's Gray.

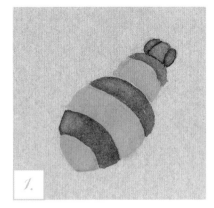

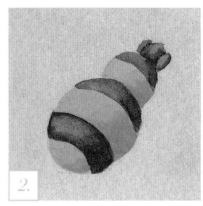

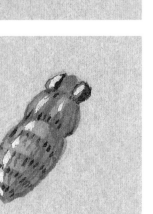

1. UNDERPAINT HONEYBEE BODIES

Paint the honeybee with a mixture of Yellow Ochre and Indian or Venetian Red. Also paint the eyes with Payne's Gray. Allow the washes to dry.

2. PAINT SHADOWS

Paint the shaded areas with darker values of each color.

3. ADD DETAILS

Add highlights with Permanent White gouache. Add accents with Payne's Gray and more of the Yellow Ochre and Indian or Venetian Red mixture.

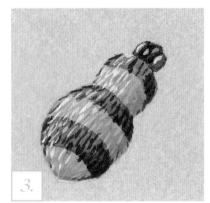

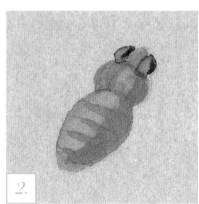

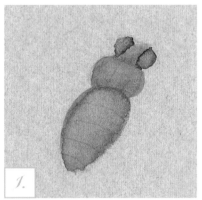

Practice Painting Flowers

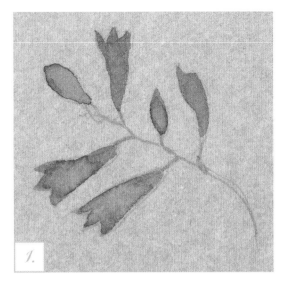

1.

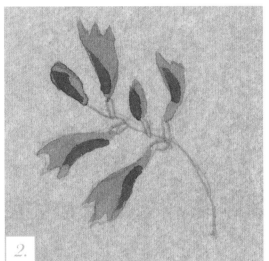

2.

1. PAINT FLOWER PETALS

Sketch the flower first. Paint each petal shape with a mixture of Cerulean Blue and Mauve. Allow the petals to dry.

2. ADD SHADOWS

Paint the shaded areas with a darker value of the same mixture.

3. ADD HIGHLIGHTS

Add highlights with Permanent White gouache. Paint the stem with a mixture of Permanent Sap Green and Payne's Gray.

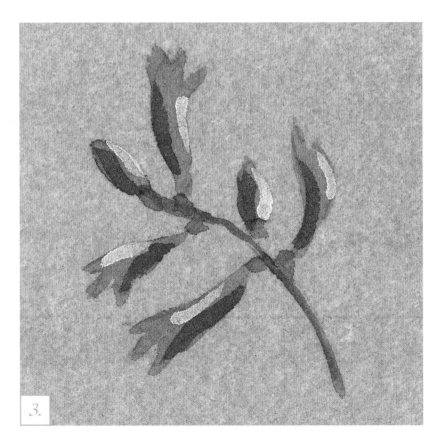

3.

1. PAINT CENTER OF DAISY

Draw two circles on your paper with a 2H lead pencil. Paint the center with a mixture of Permanent White gouache and Cadmium Yellow Light. Allow it to dry.

2. ACCENT CENTER

Paint a stroke of Cadmium Yellow Deep along the bottom edge of the center. Apply a little bit of clear water and blend the dark yellow to the top. Blot the upper edge of the wet area with a tissue to prevent a hard edge from forming.

3. ADD TEXTURE AND PETALS

Add specks to the center with Cadmium Yellow Deep. Paint the petals with Permanent White gouache, extending them to the outer circle. Erase your pencil lines after the paint dries.

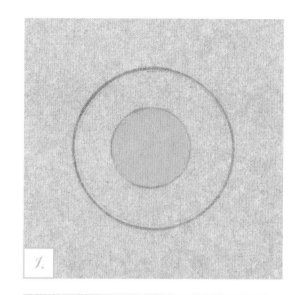

1.

2.

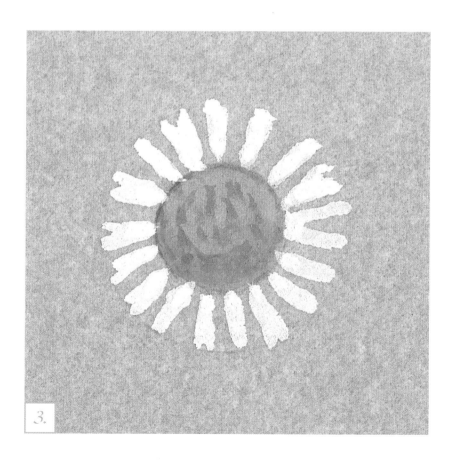

3.

Garden Dragonfly

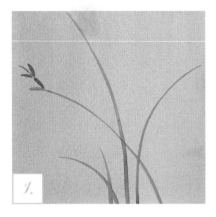

1.

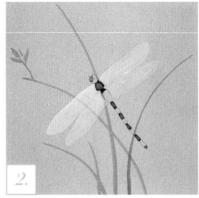

2.

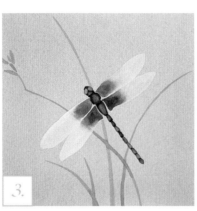

3.

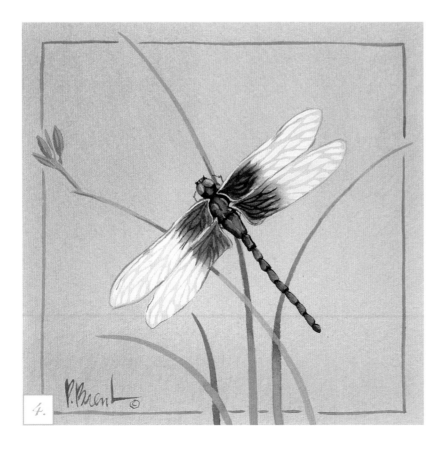

4.

P. Brent ©

1. PREPARE BACKGROUND

Frame the painting area with drafting tape. Mix an ample supply of the background color with Permanent Sap Green and Payne's Gray. You may want to mix it in a separate container to keep the large mixture separate from the other colors on your palette. I just use a white saucer. Wet the surface of your paper with clear water using a 2-inch (51mm) flat brush. Cover the paper with an even wash of color using horizontal strokes, beginning at the top and working down. Alternate vertical and horizontal coats until you get the desired tone. Then smooth the paint with alternating vertical and horizontal strokes without adding any more paint. Allow the background to dry thoroughly.

Trace the grass onto the toned paper and paint it with a mixture of Permanent Sap Green and Payne's Gray. Allow the grass to dry.

2. PAINT WINGS AND BODY SEGMENTS

Trace the dragonfly onto your paper. Paint the wings with Permanent White gouache and allow them to dry. Paint every other body segment with a mixture of Payne's Gray and a little Indian or Venetian Red, lifting some paint from each segment with clear water. Paint one eye with Permanent Sap Green.

3. PAINT WING SPOTS

Paint the dark spots on the wings with a mixture of Indian or Venetian Red and Payne's Gray. Apply a stroke of water along the edge of the spot and blend it into the rest of the wing. Blot the edge of the wet area to prevent a hard edge from forming. Paint the remaining body segments and the head with a mixture Payne's Gray and Indian Red. Complete the eye with Permanent Sap Green.

4. ADD DETAILS

Highlight the wings, segments, head and eyes with Permanent White gouache. Paint the dark line work on the wings with a mixture of Payne's Gray and Indian or Venetian Red. Add the legs near the head and outline the wings with Payne's Gray. Paint the darker areas of the leaves with a darker mixture of Permanent Sap Green and Payne's Gray. Add the border with the same mixture. When the paint is dry, remove the tape.

Garden Damselfly *and Dragonfly*

1. PREPARE BACKGROUND

Paint the background with a 2-inch (51mm) flat brush and a mixture of Mauve and Cerulean Blue and allow it to dry. Trace the drawing. Paint the grass with a mixture of Permanent Sap Green and Payne's Gray and allow the grass to dry.

2. BEGIN BODIES

Paint the wings with Permanent White gouache and allow them to dry. Paint every other body segment of the dragonfly with a mixture of Yellow Ochre and Payne's Gray. Paint every other segment of the damselfly with a mixture of Cerulean Blue and Permanent Sap Green.

3. FINISH BASE WASHES

Paint the rest of the body segments of the dragonfly with a mixture of Yellow Ochre and Payne's Gray. Paint the remaining body segments of the damselfly with a mixture of Cerulean Blue and Permanent Sap Green. Add the colored spots to the dragonfly's wings with Yellow Ochre.

4. ADD DETAILS

Add highlights to the wings and bodies with Permanent White gouache. Add legs and details to the bodies with Payne's Gray. Shade the grass with a darker mixture of Permanent Sap Green and Payne's Gray. Paint the border with a mixture of Mauve and Cerulean Blue.

1.

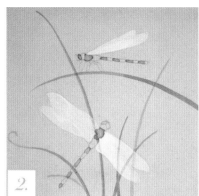

2.

3.

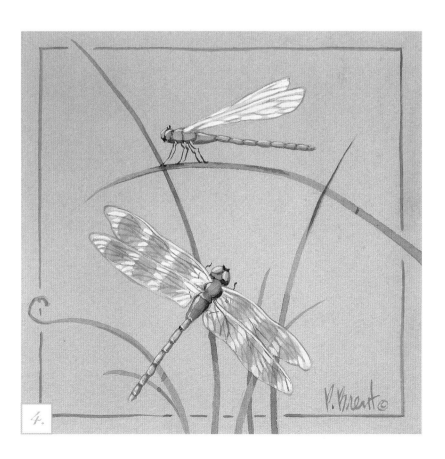

4.

Garden Bumblebee

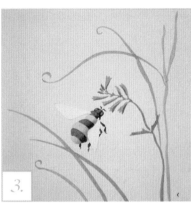

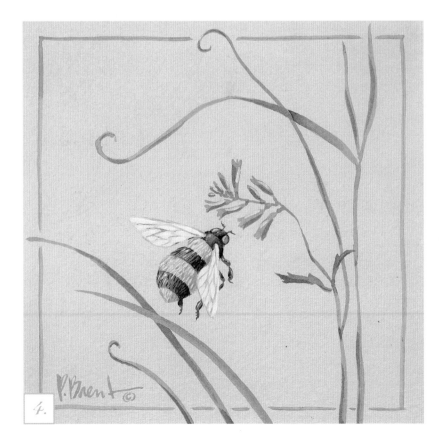

1. PREPARE BACKGROUND

Paint the background with Yellow Ochre using a 2-inch (51mm) flat brush and let it dry. Trace the drawing. Paint the grass with a mixture of Permanent Sap Green and Payne's Gray. Paint the petals with a mixture of Cerulean Blue and Mauve.

2. PAINT BASE WASHES

Paint the bumblebee's wings with Permanent White gouache and allow them to dry. Paint each body segment with either Payne's Gray or Cadmium Yellow Deep. Allow each body part to dry before painting an adjoining part.

3. ADD SHADOWS

Add darker values of each color to shade each body part. Add the legs and antennae with Payne's Gray. Shade the petals with a darker mixture of Cerulean Blue and Mauve.

4. ADD DETAILS

Paint the hairs on the bee using Permanent White gouache and Cadmium Yellow Deep for the lighter hairs, and Payne's Gray and Yellow Ochre for the darker hairs. Use Permanent White gouache to highlight the wings, eyes and petals. Lightly outline the wings with Payne's Gray, lifting the brush every once in a while to create broken lines. Shade the grass with a darker mixture of Permanent Sap Green and Payne's Gray. Paint the border with a darker value of Yellow Ochre.

Garden Honeybees

1. PREPARE BACKGROUND

Paint the background with a 2-inch (51mm) flat brush and a mixture of Vermilion and Yellow Ochre and allow it to dry. Trace the drawing. Paint the grass with a mixture of Permanent Sap Green and Payne's Gray. Paint the centers of the flowers with Cadmium Yellow Deep.

2. PAINT BASE WASHES

Paint the wings with Permanent White gouache and allow them to dry. Paint the body segments with a mixture of Yellow Ochre and Indian or Venetian Red. Drop clear water into each segment while it's still wet and let the pigment flow to the edges. Paint the eyes the same way, using a similar mixture with more Yellow Ochre.

3. ACCENT BEES

Paint the petals and the wing highlights with Permanent White gouache. Add accents to the bodies with a mixture of Yellow Ochre and Indian or Venetian Red.

4. ADD DETAILS

Paint the legs and add some accents to the bodies with Payne's Gray. Add highlights to the bodies and eyes with Permanent White gouache. Add texture to the flower centers with a mixture of Cadmium Yellow Deep and Vermilion, blending up into a stroke of clear water. When that dries, add a few small strokes of the same mixture to indicate texture. Shade the grass with a mixture of Permanent Sap Green and Payne's Gray. Paint the border with Vermilion.

I hope you can see how a simple concept using a toned background with semi-opaque watercolor and gouache can be so effective. You can apply this method to many subjects, like project 11, the Oriental Peony painting on page 104. One of the trickiest parts is getting an even background wash, so practice until you become confident.

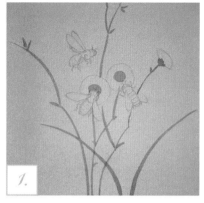
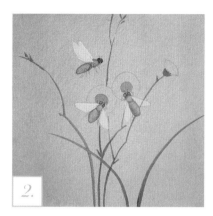
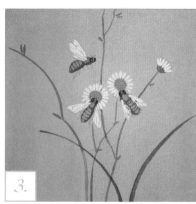
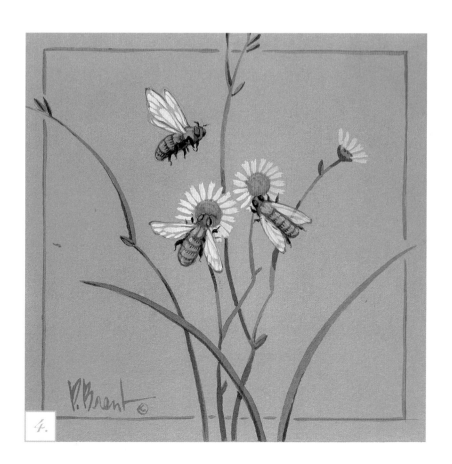

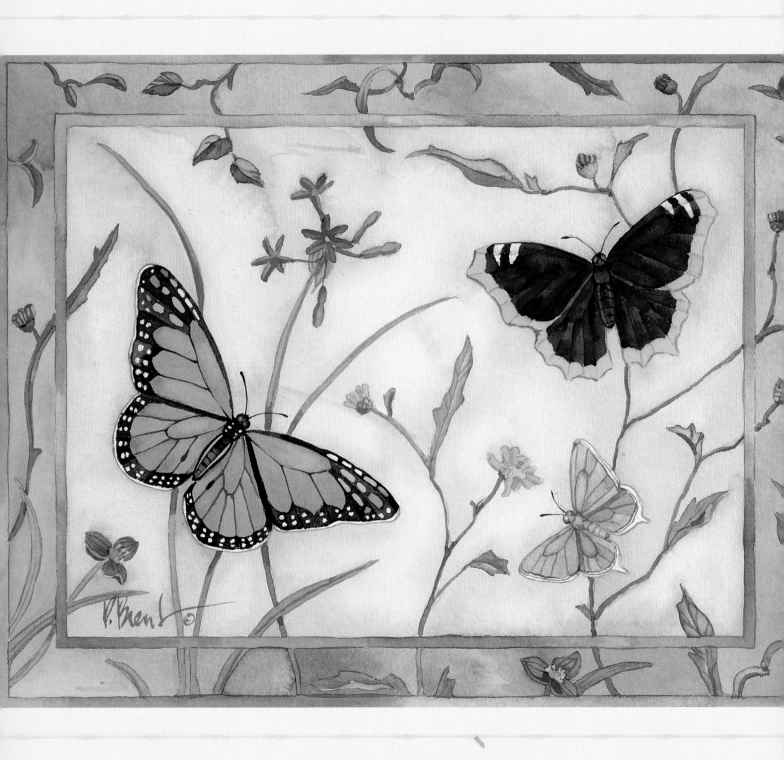

Butterfly Sampler

This collection of butterflies complements the delicate line work of the wild flowers to make a light and appealing scene. I approached the background and wildflower pattern as a stained glass artist would, using the neutral areas to offset the jewel-like character of the wings. I did this painting using all transparent colors, and its success relies on the white paper showing through each wing, flower and leaf.

MATERIALS LIST

BRUSH
no. 3 round

PALETTE
Cadmium Yellow Deep
Cadmium Yellow Light
Cerulean Blue
Indian or Venetian Red
Mauve
Payne's Gray
Permanent Sap Green
Thalo or Winsor Crimson
Thalo or Winsor Green
Ultramarine Blue
Vermilion
Yellow Ochre

SURFACE
14" x 12" (36cm x 30cm)
 300-lb. (640gsm) cold-press
 watercolor paper

OTHER
black felt-tip pen
drafting tape
eraser
facial tissue
light box
straight edge
2H lead pencil

✦ DEMO ✦

Practice Painting Butterfly Bodies *and Wings*

1. BEGIN BODY

Paint the head and abdomen with Payne's Gray. While the area is still wet, quickly clean your brush with clean water and lift some of the watercolor from the centers of the head and abdomen. Once these areas dry, paint the thorax and the center segment of the body. Paint around each white dot first. Clean your brush and lift some color from the center of the thorax.

2. ADD ACCENTS

Paint the yellow stripes on the abdomen with Cadmium Yellow Deep. Paint the eyes with a mixture of Payne's Gray and Cerulean Blue. Clean your brush and lift some of the pigment from the center of each eye.

3. PAINT ANTENNAE

Paint the antennae with Payne's Gray. Begin each stroke at the butterfly's head and draw it toward the tip. At the end of each antenna, press the brush down slightly at the end of the stroke to form the tip of each antenna. Also define the segments of the abdomen with Payne's Gray.

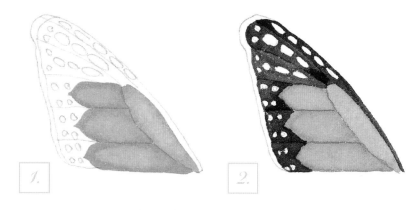

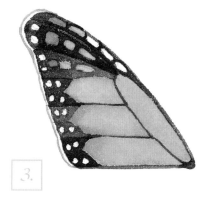

1. PAINT ORANGE SEGMENTS

Paint each orange segment with a no. 3 round brush and a mixture of Vermilion and Cadmium Yellow Deep. Keep your brush full of paint so the segment will stay wet until it's time to lift some of the pigment later. Paint within the lines. Quickly clean your brush with clear water. Blot the brush on a tissue but keep it damp. Stroke through the center of the segment you've just painted. Your brush will lift some of the pigment. Repeat if you want the area to be lighter. Be sure to paint quickly. Allow each segment to dry before painting the next.

2. PAINT BLACK AREA

Paint each black segment with Payne's Gray. Remember to let each one dry before painting an adjoining segment. It's easiest to paint around the small white dots first and then fill in the rest of each area.

3. ADD DETAILS

Paint the yellow dots with Cadmium Yellow Deep and the orange dots with a mixture of Vermilion and Cadmium Yellow Deep. Outline the wing with a mixture of Yellow Ochre and Vermilion and the orange segments with Payne's Gray.

✦ DEMO ✦
Practice Painting Flowers *and Leaves*

1. **UNDERPAINT PETALS**

Paint each petal with a mixture of Ultramarine Blue and Mauve. While the area is still wet, clean your brush and lift some of the watercolor from the center of each petal.

2. **PAINT GREENERY**

Paint the rest of the petals as you did in Step 1. Paint the turned edge of the petal with a lighter mixture of Ultramarine Blue and Mauve. Paint the stem and green parts of the flower's center with Permanent Sap Green. Allow these areas to dry.

3. **PAINT FLOWER CENTER**

Add yellow to the flower's center with Cadmium Yellow Deep.

4. **PAINT VEINS**

Paint veins on the petals with Ultramarine Blue and Mauve. Begin each stroke at the center of the flower and lift the brush as you move toward the edge. Add shading to the green areas with Permanent Sap Green.

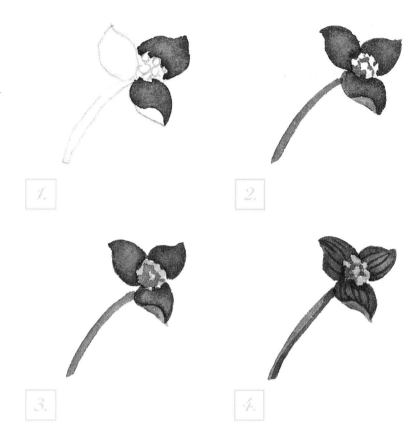

1.

2.

3.

4.

1. **UNDERPAINT LEAF**

Paint the top part of the leaf with Permanent Sap Green. While the watercolor is still wet, clean your brush and lightly blot it on a tissue. Lift some of the watercolor from the center of the area. Then paint the lower half and lift pigment the same way.

2. **PAINT VEINS**

Paint the vein details with a mixture of Permanent Sap Green and Thalo or Winsor Green. Begin each stroke at the center, lifting as you pull the brush away from the center so the line becomes thinner toward the edge of the leaf.

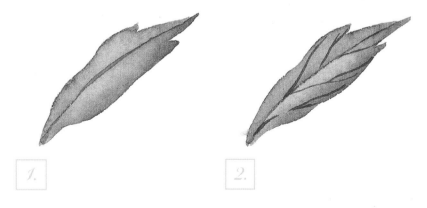

1.

2.

Butterfly Sampler

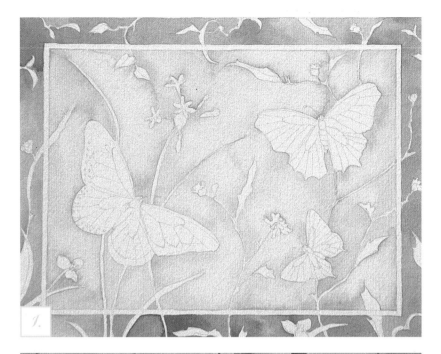

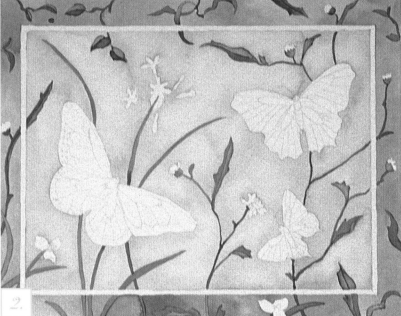

1. PREPARE BACKGROUND

Wash a sheet of watercolor paper with clear water. Frame the painting area with drafting tape. Draw the butterflies and background elements on tracing paper and outline the drawing with a felt-tip pen. Tape the tracing paper face down onto the back of the watercolor paper. Trace the drawing onto the watercolor paper with a pencil, using a light box or window as backlight. Use a straight edge to draw the borders.

Paint the background by washing clear water in the center of the spaces between each element. Then paint around the edges of the objects with Yellow Ochre. Allow the watercolor to bleed into the water. When it dries, the background will appear to glow.

Paint the border with the same technique, switching between Vermilion, Thalo or Winsor Crimson, Mauve, Permanent Sap Green and Ultramarine Blue. Make the background of the border more intense than the rest of the background.

2. START LEAVES

Paint the top half of each leaf and all of the single leaves with Permanent Sap Green. After you paint each segment, clean your brush and lift pigment from the center with a wet brush to add dimension. When these dry, paint the rest of the segments and the stems with Permanent Sap Green. Add Indian Red to darken some of the stems.

3. ADD COLOR

Paint the purple flowers in the center with Mauve, the blue flowers with Ultramarine Blue and the yellow flowers with Cadmium Yellow Light. Paint the non-adjoining segments of the orange monarch with a mixture of Vermilion and Cadmium Yellow Light. Paint the non-adjoining segments of the blue butterfly, an eastern tailed blue, with Cerulean Blue. Immediately after painting each petal or wing segment, clean your brush with clear water and lift pigment from the center of the segment. To paint the darkest butterfly, a mourning cloak, use a medium value of Mauve. Then drop Payne's Gray around the edges of the segment with the tip of the brush.

4. FINISH SEGMENTS

Paint the rest of the wing segments and flower petals, lifting pigment from the appropriate areas. Paint the grayish leaf behind the purple flowers with a mixture of equal parts Indian Red and Cerulean Blue.

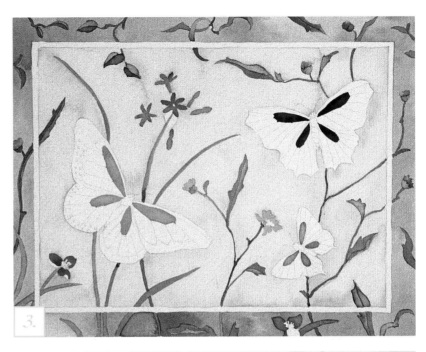

3.

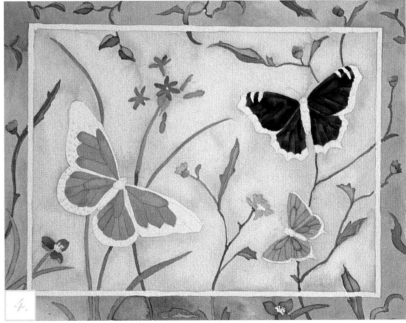

4.

Butterfly Sampler, *continued*

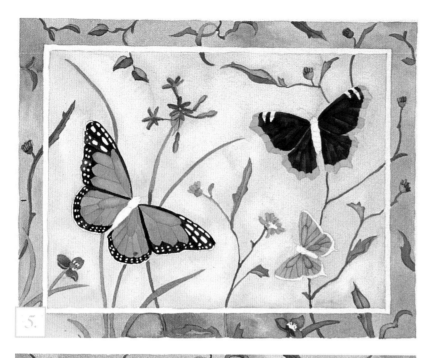

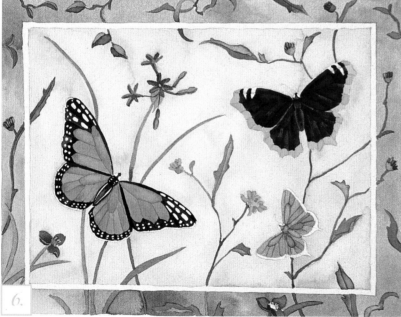

5. FINISH WINGS

Paint the black parts of the monarch's wings with Payne's Gray. Don't lift paint from these areas. Remember to let segments dry before painting adjacent ones. Paint the yellow parts of the mourning cloak's wings with Cadmium Yellow Deep. Lift pigment from each of the yellow segments. Paint a second layer of deeper shades of the same colors on each flower. On the yellow flowers use a mixture of Cadmium Yellow Deep and a touch of Vermilion. To provide variation to the white segments of the wings of the mourning cloak, add a light stroke of a mixture of Cerulean Blue and a touch of Mauve to the lower edge of each segment.

6. PAINT BODIES

Paint the monarch's body and head with Payne's Gray and the eastern tailed blue's body with Cerulean Blue. Lift pigment from each segment after painting it. Paint strokes of Mauve on each side of each body segment of the mourning cloak. Then, while the paint is still wet, add a stroke of Payne's Gray to the center of each segment, allowing it to bleed into the Mauve. Paint the mourning cloak's head with Payne's Gray and lift pigment. Paint the flower centers with Cadmium Yellow Light.

Many artists might have simplified the wings of the butterfly by painting one wash over each wing and then painting the line work. But I think painting each segment separately really captures the reflective light on the wings and makes for a much more interesting rendition of these beautiful creatures.

7. ADD LINEAR DETAILS

Outline the wing and body segments and paint the antennae on the monarch with Payne's Gray. Paint the yellow spots on the wings and the body with Cadmium Yellow Deep and the orange spots with a mixture of Cadmium Yellow Deep and Vermilion. Outline the wing segments of the eastern tailed blue with a mixture of Cerulean Blue and Payne's Gray. Paint the antennae of the eastern tailed blue and the mourning cloak and outline the mourning cloak's body segments with Payne's Gray. Paint the monarch's and mourning cloak's eyes with Payne's Gray. Clean your brush and drop clear water into the center of each eye, allowing the paint to bleed into the center. If the paint bleeds too much, you can lift some of the pigment. Paint the eastern tailed blue's eyes with the same technique and a mixture of Cerulean Blue and Payne's Gray. Add shadows and veins on the leaves with a mixture of Permanent Sap Green and Thalo or Winsor Green. Add vein detail to the blue flowers with Ultramarine Blue.

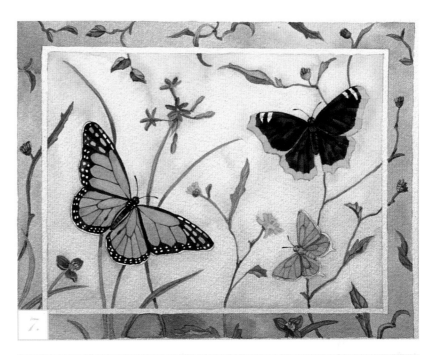

8. PAINT BORDER

Fill in the thin borders: Lay down a stroke of clear water about one-inch (25mm) long in one of the borders. Lay down a stroke of Ultramarine Blue next to the water so the paint bleeds into the water. Switch between Ultramarine Blue, Cerulean Blue, Thalo or Winsor Green and Mauve as you move around the border. Work quickly so the water doesn't dry and the transitions from one color to the next blend well. When you've worked around the border and have reached your starting point, apply another stroke of water overlapping your starting point. Allow the last color to bleed into the first color. Repeat this process for the other border. Carefully remove the drafting tape. Never keep the tape on the paper longer than three days. It can dry on the paper and tear the surface when you remove it. Erase any remaining pencil lines and touch up any white areas you might have missed.

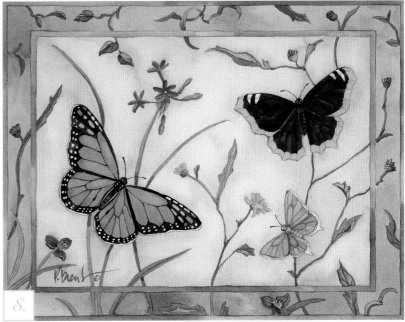

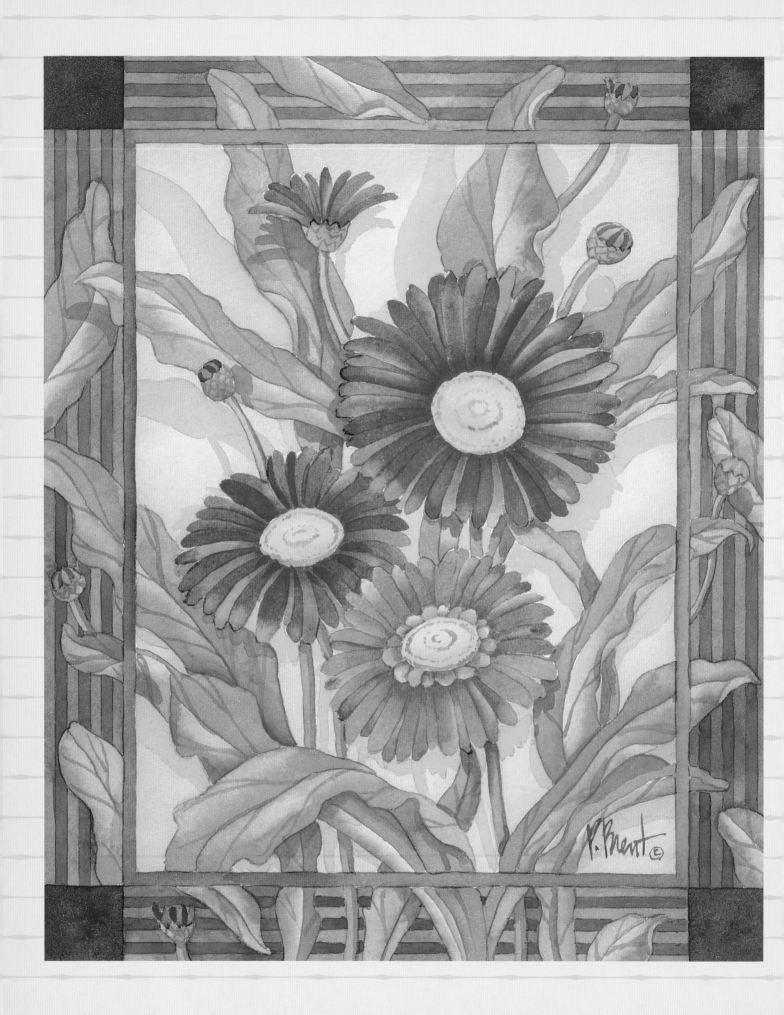

Gerbera Daisies

◆ *Gerbera daisies are prized for their bright and cheerful colors. The key to capturing their essence lies in the brightness of the flower petals. Watercolor often is considered a pastel-colored medium, but you can choose colors and layer the washes to give your painting the same intense color as the flowers themselves. Contrast between dark and light areas in your painting also can indicate brightness. Remember to keep highlight areas light as you apply layers of paint.*

MATERIALS LIST

BRUSH
no. 3 round

PALETTE
Cadmium Yellow Deep
Cadmium Yellow Light
Cerulean Blue
Grumbacher or Winsor Red
Permanent Green Light
Thalo or Winsor Crimson
Thalo or Winsor Green
Ultramarine Blue
Vermilion

SURFACE
20" x 15" (51cm x 38cm)
 300-lb. (640gsm) cold-press
 watercolor paper

OTHER
black felt-tip pen
drafting tape
eraser
facial tissue
straight edge
2H lead pencil

Painting Leaves

1. PAINT TOP HALF

Paint the upper half of each leaf with Permanent Green Light. Lift pigment from the center of the segment.

2. FINISH UNDERPAINTING

Paint the outer edge of the bottom of the leaf with Permanent Green Light. While this is still wet, clean your brush and paint the inner portion of the segment with clear water. Allow the color to bleed into the clear water. Dry your brush on a tissue and blend the area between the watercolor and the clear water.

3. PAINT VEINS

Paint the veins with a mixture of Permanent Green Light and Thalo or Winsor Green. Begin each stroke at the center of the leaf, lifting your brush so the stroke narrows toward the edge.

1.

2.

3.

◆ DEMO ◆

Painting Daisy Petals and Centers

1. ADD FIRST COLOR TO PETALS

Fill in the general shape of the petals with clear water. Paint a stroke around the center of the flower with Thalo or Winsor Crimson and allow the color to bleed outward into the clear water. Blot the outer edges of the pigment with a tissue to prevent a hard edge from forming. Allow the area to dry. This color will give the daisies a three-dimensional appearance.

2. PAINT PETALS

Trace the individual petal shapes. Then paint non-adjoining petals with the same color you used in Step 1. After painting each petal, clean your brush, keeping it damp, and lift pigment from the center.

3. FINISH PETALS

When these petals have dried, paint the rest the same way. Vary the values, making some lighter and others darker.

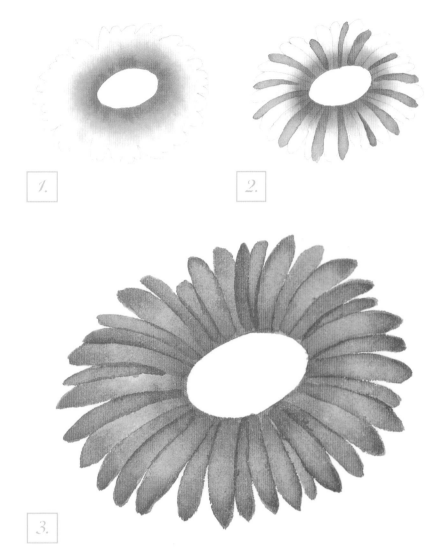

1.

2.

3.

1. UNDERPAINT CENTER

Underpaint the center of the daisy with Cadmium Yellow Deep. Lift some pigment from the top left. Allow area to dry.

2. ADD DETAILS

Add texture and shadow to the center with a mixture of Cadmium Yellow Deep and Vermilion.

1.

2.

Gerbera Daisies

1. PREPARE BACKGROUND

Wash a piece of watercolor paper. Trace or draw the drawing onto tracing paper and then onto the watercolor paper as you did for the Butterfly Sampler. Tape the outer edges of the painting with drafting tape. Paint the corners of the painting with Ultramarine Blue. Drop some extra paint around the edges of the squares to vary the color. Paint the background behind the flowers with Cadmium Yellow Light by first washing the center of a segment of the background with clear water. Then paint around the edges of the segment with watercolor, allowing the color to bleed into the middle. Repeat this process until you've covered the background. Allow the paint to dry.

2. START LEAVES

Paint the upper half of each leaf with Permanent Green Light. Lift pigment from the center of each segment to give the leaf dimension. Allow the paint to dry before moving on to an adjoining segment. Also be careful when painting near the yellow background. Many yellows have a tendency to pull color and create a bleed, especially when very wet. Try to apply color next to the background using a minimal amount of water.

3. PAINT FLOWER CENTERS

Paint the outer edge of the lower half of each leaf with Permanent Green Light. Fill in the inner portion of the segment with water and let the green bleed toward the center of the leaf. Blend the water and paint with a dry brush. Also paint the stems and bud bases with Permanent Green Light. Lift some paint from the left side of each bud base with a tissue while the paint is still wet to create highlights. Paint the centers of the daisies with Cadmium Yellow Light. Lift some of the pigment from the upper half of each center to create a highlight and a rounded look.

4. BEGIN PETALS

Lay clear water down around the center of each daisy, filling about half of the general flower shape. Stroke color around the center of each flower with Thalo or Winsor Crimson for the pink flower, Grumbacher or Winsor Red for the red flower and a mixture of Vermilion and Cadmium Yellow Deep for the orange flower. Leave some white space surrounding the center of the bigger orange flower. Paint each daisy separately and allow the color to bleed toward the outer edge. Leave the tips of the petals white, using a tissue to keep the color from spreading if it bleeds too far. Use these same colors and Cadmium Yellow Deep to paint the flower buds. While the paint is still wet, lift some pigment from one side of each bud.

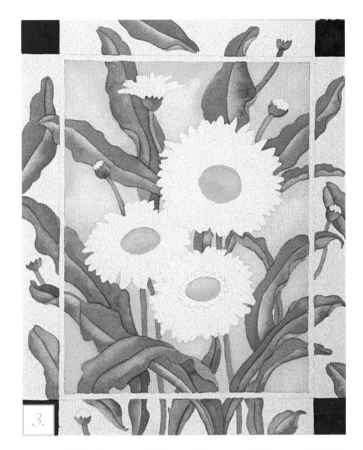

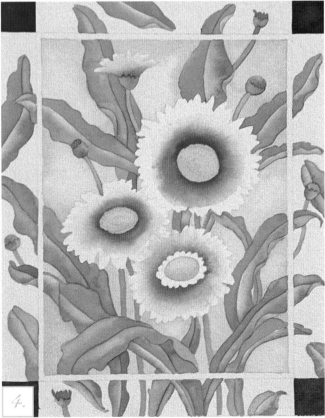

Gerbera Daisies, *continued*

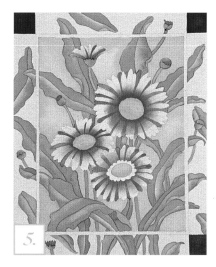

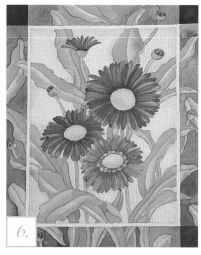

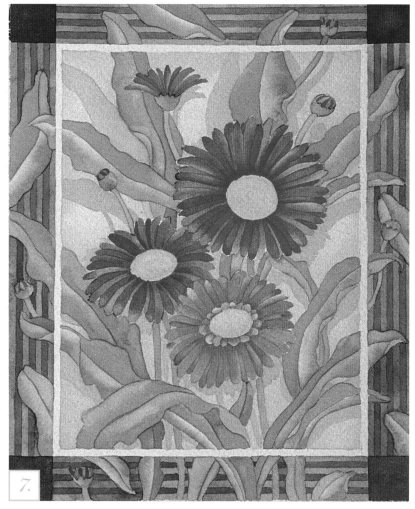

DEFINE PETALS

Once the paint from Step 4 has dried, define the individual petals with a pencil. Paint the rest of the petals. Immediately after painting each one, clean your brush and lift pigment from the center. If a petal overlaps petals from another flower, lift pigment from the tip of the overlapping petal to make the flowers blend together better.

6. **PAINT BORDER**

Finish painting the petals as you did in Step 5. Vary some of the values. Paint alternating petals on each bud with a darker mixture of the original color. Paint the border's background with a flat wash of Cerulean Blue. Paint the inner circle of petals near the center on the orange daisy with a mixture of Vermilion and Cadmium Yellow Deep, letting each petal dry before painting an adjacent one.

7. **BEGIN SHADOWS**

Draw the shadows of the leaves and flowers in the background. Use a straight edge to draw the lines on the border. Paint the dark stripes on the border with a mixture of Cerulean Blue and Ultramarine Blue. Paint the shadows over the yellow background with a mixture of Cadmium Yellow Light and Cadmium Yellow Deep.

8. ADD DEPTH

Add the green shadows over the stems and leaves with a mixture of Permanent Green Light and Thalo or Winsor Green. Notice how much depth you've just added to the painting. After the shadows dry, add veins to the leaves and details to the bud bases with the same mixture. Add details to the yellow flower centers with a mixture of Cadmium Yellow Deep and Vermilion.

9. FINISH BORDER

Paint the thin border with a mixture of Vermilion and Cadmium Yellow Deep. Lay down a strip of clear water and then a strip of a mixture of Cadmium Yellow Deep and Vermilion next to it so the color bleeds into the water. Work quickly, overlapping strips of color as you move around the water to prevent hard edges. When you get back to your starting point, overlap the area with water and then color and blend the areas. Then add another strip of clear water so the border looks seamless. You can blot your final stroke to blend the spot even more. Carefully remove the drafting tape and erase any pencil lines that are still visible.

It's always so exciting to watch the final details make a painting come alive. This is one of those paintings that seems like a "sleeper" until the final layers of paint bring out the brightness and dimension of the subject.

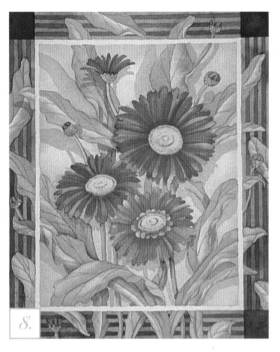

8.

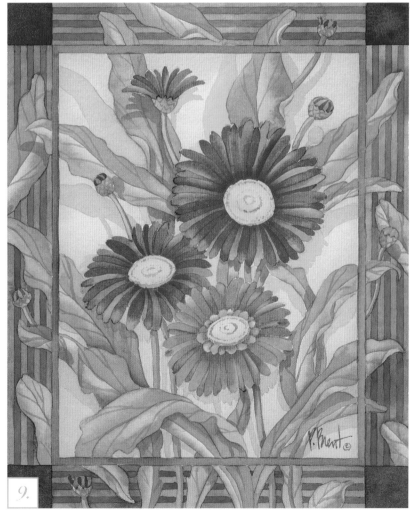

9.

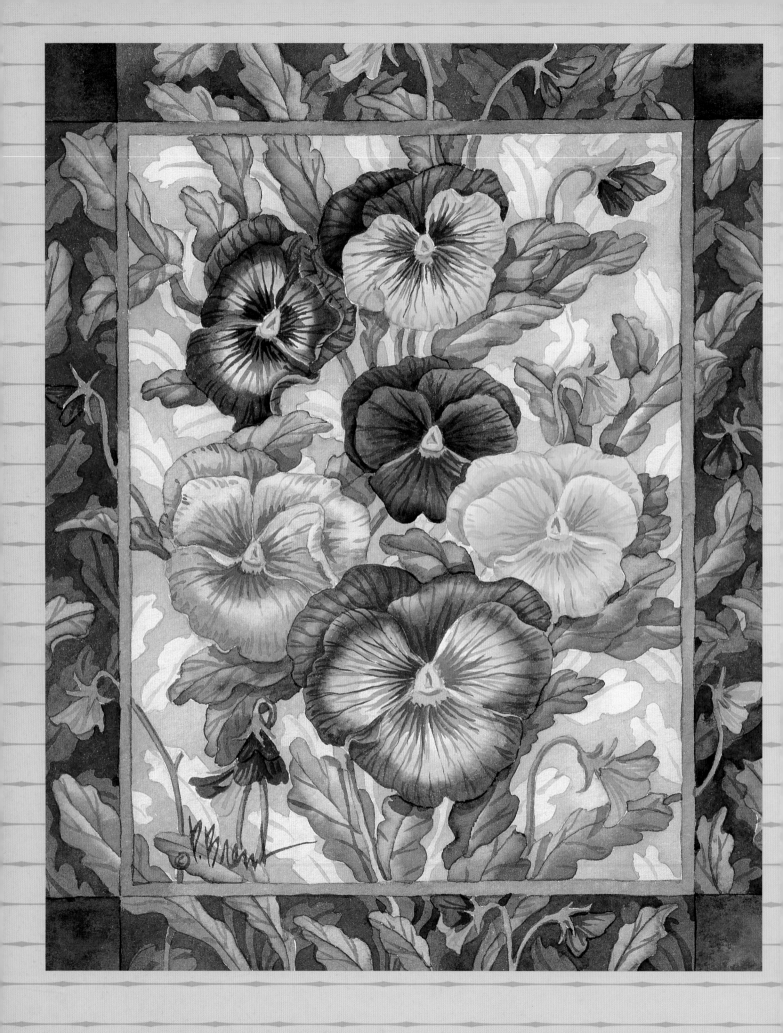

Pansy Family

◆ *Pansies are among the most popular garden flowers and can grow in climates throughout the world. A relative of the violet, the pansy is a spring flower that likes cooler temperatures. Its fabled "face" has captured the imagination of many artists throughout the years. This painting includes just a few of the many variations of color in the pansy family. I hope you enjoy painting these lovely flowers and adding your own color variations.*

MATERIALS LIST

BRUSH
no. 3 round

PALETTE
Cadmium Yellow Deep
Cerulean Blue
Grumbacher or Winsor Red
Mauve
Permanent Sap Green
Thalo or Winsor Green
Ultramarine Blue
Vermilion
Yellow Ochre

SURFACE
14" x 12" (36cm x 30cm)
 300-lb. (640gsm) cold-press
 watercolor paper

OTHER
black felt-tip pen
drafting tape
eraser
facial tissue
straight edge
2H lead pencil

Painting Petals

1. START PETAL

Lay a wash of clear water over each petal. Paint a stroke of Mauve along the bottom edge, allowing it to bleed into the water. Drop a few more spots of pigment at the outer edge of the petal with the tip of your brush. Allow the area to dry completely.

2. ADD YELLOW

Lay another wash of clear water over the rest of the petal. Paint a stroke of Cadmium Yellow Deep just above the stroke of Mauve. Allow the yellow to bleed into the water. Again let the area dry completely.

3. UNDERPAINT VEINS

Paint a small stroke of Mauve on the outer edge of the part of the petal that folds over. While this paint is still wet, clean your brush and paint a stroke of clear water on the lower edge of this fold. Allow the Mauve to bleed into the water. Blot the edge of the petal with a tissue if necessary to prevent it from bleeding too much. The detail on this fold helps define it from the rest of the petal. Paint the very light veins emanating from the center of the flower with very pale Mauve, beginning at the center of the flower and pulling the strokes outward. Allow the paint to dry.

4. FINISH VEINS

Paint the darker veins with a normal value of Mauve, allowing the lighter veins to peek through.

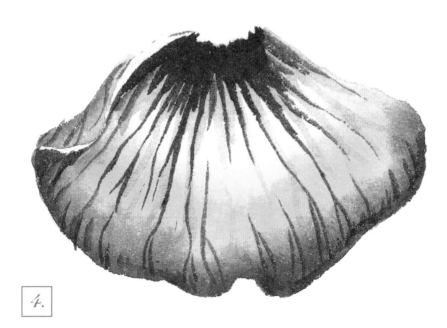

✦ DEMO ✦

Painting Leaves *and Background*

1. UNDERPAINT LEAF

Paint the upper half of the leaf with Permanent Sap Green. While the paint is still wet, lift some of the pigment from the center of the segment. When this has dried, paint the lower segment. Clean your brush and lift some pigment from the top of this segment along the center vein.

2. ADD VEINS

Paint the leaf veins with a mixture of Permanent Sap Green and Thalo or Winsor Green. Begin each stroke at the center vein and pull your brush away from the center, decreasing pressure as you go so the line narrows toward the outside edge of the leaf.

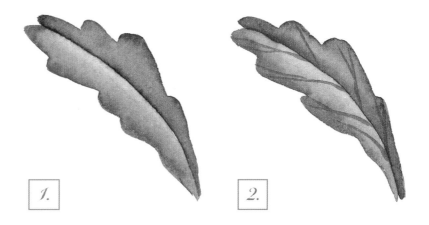

1.

2.

1. UNDERPAINT BACKGROUND

Cover a section of the background with clear water. Don't lay water over areas that won't be part of the background. You'll have traced the base drawing for your painting onto watercolor paper. The white part of this section of the background will be a leaf in the painting. Apply a mixture of Yellow Ochre and Vermilion around the edge of each background section and allow the watercolor to bleed into the center. Let the area dry.

2. DEFINE LEAVES

Sketch some leaf shapes over the painted background. Paint around these shapes with a mixture of Yellow Ochre and Vermilion that is slightly more intense than the initial wash. Paint a single stroke up the center vein of each leaf with the same mixture. Begin at the base of the leaf and taper your stroke toward the tip.

1.

2.

Pansy Family

1. PREPARE BACKGROUND

Trace the drawing onto watercolor paper. Use a straight edge to draw the borders. Frame the painting with drafting tape. Apply clear water to the center of a section of the background. Then apply a mixture of Yellow Ochre and Vermilion around the outer edges of the section, allowing the color to bleed into the center. Paint the corners of the border with a mixture of Mauve and Vermilion. While the paint is still wet, drop more Mauve around the edges of the squares with the tip of your brush.

2. PAINT LEAVES

Paint the upper part of each leaf with Permanent Sap Green. Paint them one at a time, and while the paint is still wet, lift some pigment from the center of the segment to add dimension. Paint the remaining leaf segments and the stems with the same color, this time lifting pigment along the center vein of the leaf. The lower edge of the leaf should be the darkest part in order to indicate that the light source is shining from above.

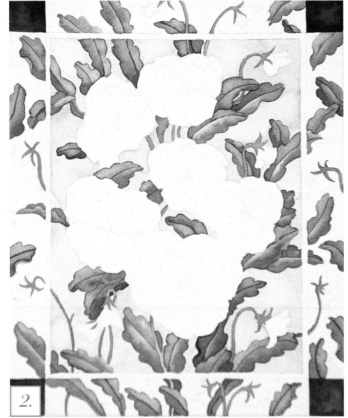

3. PAINT PETALS

Begin the petals of the flowers and buds, using Mauve
for the purple petals, a mixture of Cerulean Blue and a
little Mauve for the blue petals, Cadmium Yellow Deep
for the yellow petals and a mixture of Mauve and
Grumbacher or Winsor Red for the burgundy petals.
Paint non-adjoining petals first. Lay a wash of clear
water on the part of each petal closest to the center of
the flower. Then add a stroke of watercolor to the edge
of the petal, allowing it to bleed into the clear water.
Dab the area with a tissue if the pigment bleeds farther
toward the center of the flower than you'd like. Lift pig-
ment from the outer petals of each pansy to create
dimension. Then paint the rest of the petals and bud
bases, making sure each petal is dry before painting one
next to it.

4. UNDERPAINT BORDER

Paint the background of the border with a mixture
of Permanent Sap Green and Thalo or Winsor Green.
Vary the mixture as you paint so each color periodically
forms the predominant color of the mixture. Also, vary
the value as you paint so it's darker around the leaves
and stems than around the greenery. This helps define
the greenery from the background. Lay a clear wash
over each of the three front petals of the purple pansy
and over the lower petal of the burgundy pansy. While
still wet, add a stroke of Cadmium Yellow Deep to each
petal and allow it to bleed into the clear water. Paint
each petal individually.

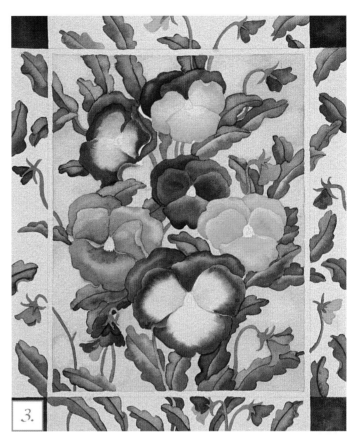

3.

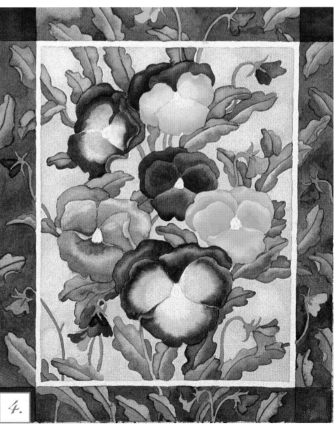

4.

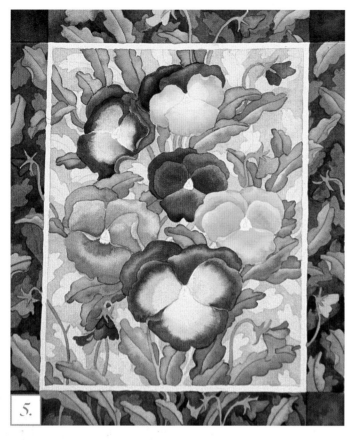

5.

5. ADD DETAILS TO BACKGROUND

Lightly draw leaf shapes over the painting's and border's backgrounds. Paint around the leaves behind the pansies with a mixture of Yellow Ochre and a little Vermilion. Paint around the leaf shapes in the border with a mixture of Thalo or Winsor Green and a small amount of Permanent Sap Green.

6. PAINT LEAF VEINS

Add center veins to these leaves, using Thalo or Winsor Green for the border leaves and a mixture of Yellow Ochre and Vermilion for the center's background leaves. Paint the center of each pansy with Cadmium Yellow Deep.

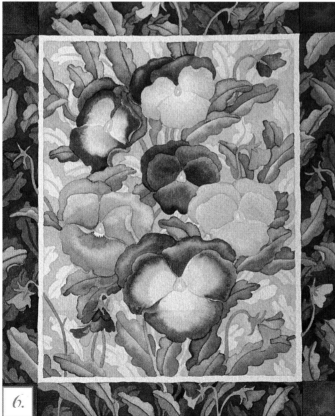

6.

7. BEGIN SHADOWS

Add veins and shadows to the regular leaves with Thalo or Winsor Green. Add veins to the blue pansies with a mixture of Cerulean Blue and Mauve, to the purple pansy with light Mauve; to the burgundy pansies with a mixture of Mauve and Grumbacher or Winsor Red; to one yellow pansy with a mixture of Cadmium Yellow Deep and Vermilion and to the completely yellow pansy with just Cadmium Yellow Deep. Also, shade the center of each pansy with Cadmium Yellow Deep. Add veins to the buds with the same colors.

8. ADD MORE VEINS

Add more veins, using Mauve for the purple and burgundy pansies; a mixture of Cerulean Blue and a little Mauve for the blue pansy and a mixture of Cadmium Yellow Deep and Vermilion for the uppermost yellow pansy. Paint the thin line of the border with Ultramarine Blue as usual. Remove the drafting tape and erase any remaining pencil lines.

Talk about personality! I've found that pansies, without exception, make people smile. Once more, details are important in creating the "faces" on each flower. The turned edges of the petals and leaves help maintain movement in this painting.

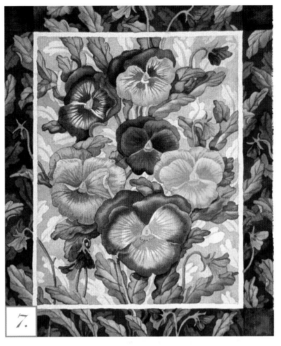

7.

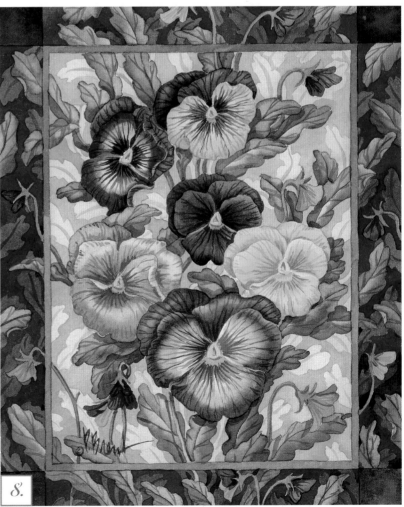

8.

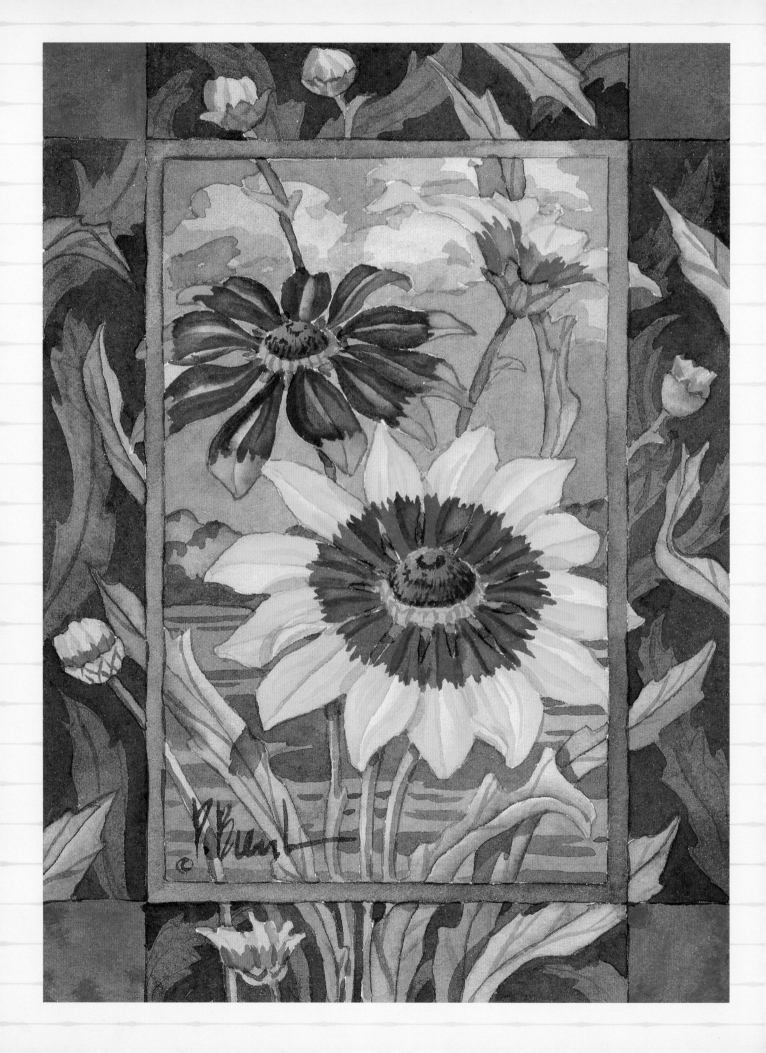

Gloriosa Daisies

The vivid colors of the gloriosa daisy make it a spectacular project for both the artist and the gardener. I chose to place the bright yellows, oranges and rusts against a perfectly blue sky. The border frames the painting much like a window looking into the quiet corner of a garden.

MATERIALS LIST

BRUSH
no. 3 round

PALETTE
Cadmium Yellow Deep
Cerulean Blue
Indian or Venetian Red
Mauve
Permanent Sap Green
Thalo or Winsor Crimson
Thalo or Winsor Green
Ultramarine Blue
Vermilion

SURFACE
11" x 9" (28cm x 23cm)
 300-lb. (640gsm) cold-press
 watercolor paper

OTHER
black felt-tip pen
drafting tape
eraser
facial tissue
straight edge
2H lead pencil

Painting Flower Petals and Centers

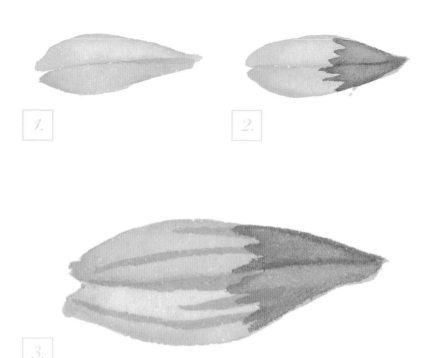

1.

2.

1. START PETAL

Paint half of the petal with Cadmium Yellow Deep. While it's still wet, clean your brush and lift some of the pigment from the center of the segment. Allow the paint to dry. Paint the other half the same way and allow it to dry.

2. ADD ORANGE

Paint the orange area of the first half of the petal with a mixture of Vermilion and Thalo or Winsor Crimson. While the area is still wet, lift some pigment from the center of the wet area. Allow the paint to dry. Paint the orange area on the second half of the petal the same way and let the paint dry.

3. DEFINE RIDGES

Define the ridges of the petals with vertical strokes of a mixture of Cadmium Yellow Deep and Vermilion.

3.

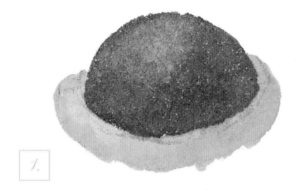

1.

1. UNDERPAINT CENTER

Paint the brown part of the center with a mixture of Indian or Venetian Red and Mauve. Blot the upper left edge with a tissue. Let the paint dry. Paint the yellow edge with Cadmium Yellow Deep. Blot the left side of this area with a tissue.

2. ADD TEXTURE

Add texture to the center with darker mixtures of Indian or Venetian Red and Mauve for the brown area and a mixture of Cadmium Yellow Deep and Vermilion for the yellow area.

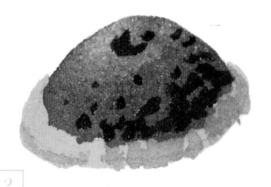

2.

✦ DEMO ✦
Painting Clouds

1. **UNDERPAINT CLOUD BACKGROUND**

Paint the background with a light wash of Cerulean Blue. Allow the paint to dry.

2. **DEFINE CLOUD SHAPES**

Lightly sketch the cloud shapes with a pencil. Paint around these cloud shapes with a darker mixture of Cerulean Blue. Again allow the paint to dry.

3. **ADD SHADOWS**

Paint the shadows on the clouds with a mixture of Cerulean Blue and Mauve.

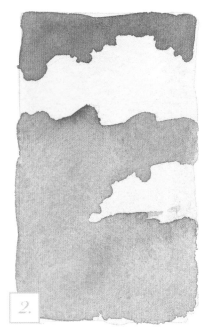

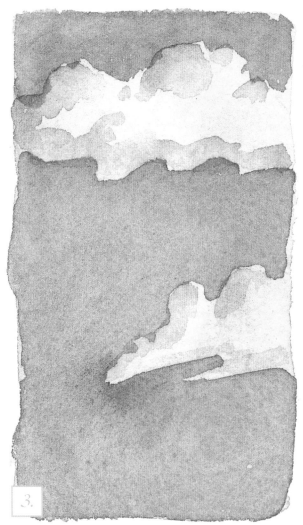

Gloriosa Daisies

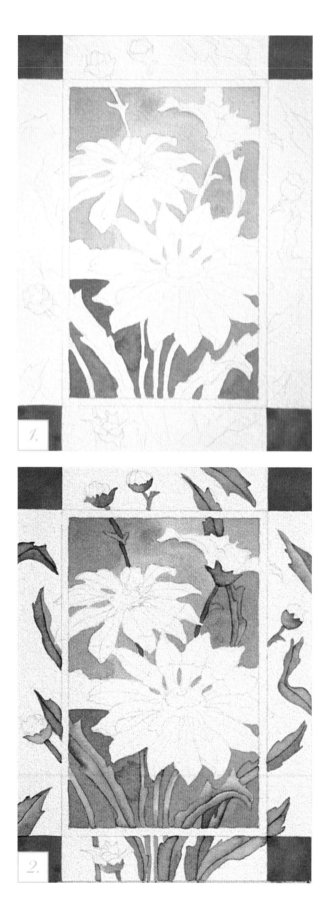

1. PREPARE BACKGROUND

Wash a piece of watercolor paper. Trace the base drawing onto tracing paper and then onto the watercolor paper. Tape the outer edges of the painting with drafting tape. Paint the corners of the border with a mixture of Vermilion and a small amount of Mauve. While each square is still wet, drop small amounts of a darker mixture of the same colors into the squares to vary the color a bit. Paint the sky with a light wash of Cerulean Blue. Paint the grass with Permanent Sap Green. Allow all areas to dry.

2. PAINT LEAVES

Paint the upper part of each leaf with Permanent Sap Green. While each segment is still wet, lift color from the center of each segment to make the leaves stick out from the green background. Paint the rest of the leaves and the buds the same way, allowing adjoining areas to dry before painting the next part.

3. PAINT PETALS

Paint half of each petal, using Cadmium Yellow Deep for the yellow flowers and buds and a mixture of Vermilion and Mauve for the cinnamon-colored flower. Leave the tips of the cinnamon petals white so you can accent them with a lighter yellow later. While each segment is wet, lift some pigment from the center line of the petal. After these dry, paint the rest the same way, this time lifting the pigment along the petal's center vein.

4. PAINT BORDER BACKGROUND

Paint the border's green background and the tree line behind the flowers with a mixture of Permanent Sap Green, Thalo or Winsor Green and Cerulean Blue. When painting the border, make the mixture a bit darker near the leaves to help define their shapes.

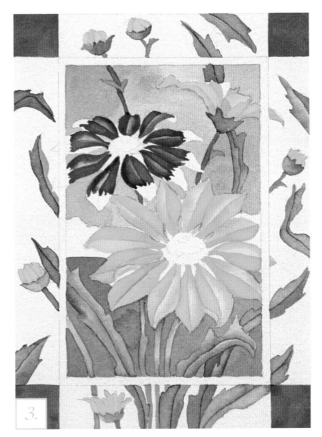

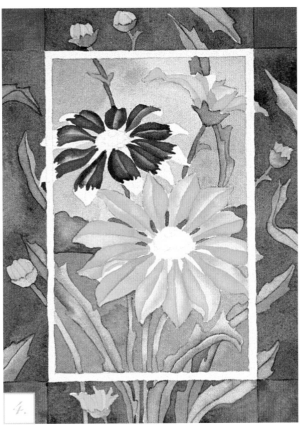

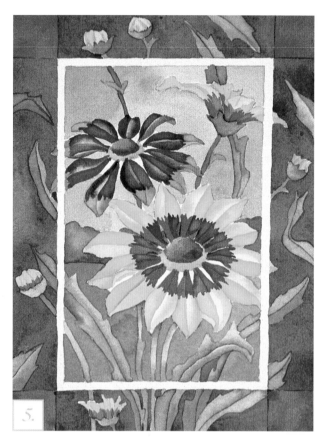

5. **ACCENT PETALS**

Paint the tips of the cinnamon petals in segments with a mixture of Vermilion and Cadmium Yellow Deep. Let each segment dry before painting the one next to it. Lift pigment from the center of the first segment and from the area next to the petal's vein on the second half. Add the red accents to the yellow petals and buds with a mixture of Vermilion and Thalo or Winsor Crimson, painting in segments. Paint the brown centers of the flowers with a mixture of Vermilion and Mauve. Lift some pigment from the upper left parts of these centers with a tissue to highlight them and make them appear round. Paint the yellow edge of each center with Cadmium Yellow Deep and lift some pigment from the left side with a tissue. Let the painting dry.

6. **DEFINE SHAPES**

Lightly draw leaf shapes over the border background, clouds over the sky and shadows over the grass. Paint around the leaf shapes and paint the shadows with a mixture of Thalo or Winsor Green and Permanent Sap Green. Also, fill in some of the white space near the center of the yellow flower with this mixture. Paint around the cloud shapes with a mixture of Cerulean Blue and Mauve.

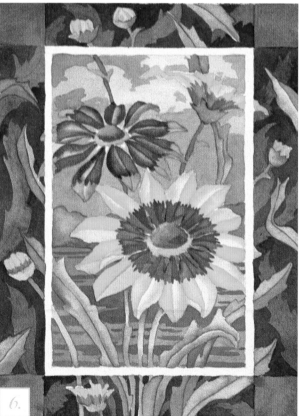

7. ADD DETAILS

Paint the leaf veins with Thalo or Winsor Green. Always start at the center vein and pull your stroke toward the edge of the leaf, lifting the brush as you go so the veins taper. Add the zigzag details to the bud bases with Thalo or Winsor Green. Paint the shadows on the background trees with a mixture of Thalo or Winsor Green and Cerulean Blue. Add some linear detail to the yellow flower petals with Cadmium Yellow Deep. Add detail to the cinnamon flower and to the center of the yellow flower with a mixture of Vermilion and Mauve.

8. ADD FINAL DETAILS

Paint the shadows on the clouds with a mixture of Cerulean Blue and Mauve. Accent the brown centers of the flowers with a mixture of Vermilion and Mauve. Detail the yellow parts of the centers with a mixture of Cadmium Yellow Deep and Vermilion. Paint the thin blue border with Ultramarine Blue. Carefully remove the drafting tape and erase any pencil lines that remain.

The basic landscape in the background adds great depth to this painting. By simply changing the shade of blue, you could change the whole mood of the painting.

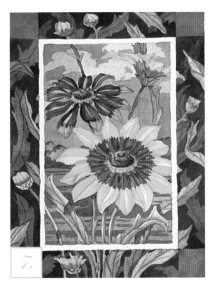

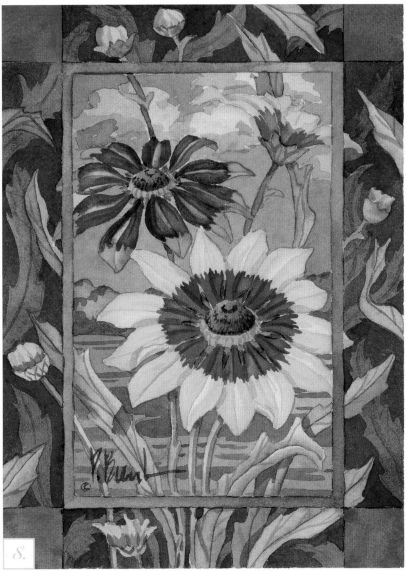

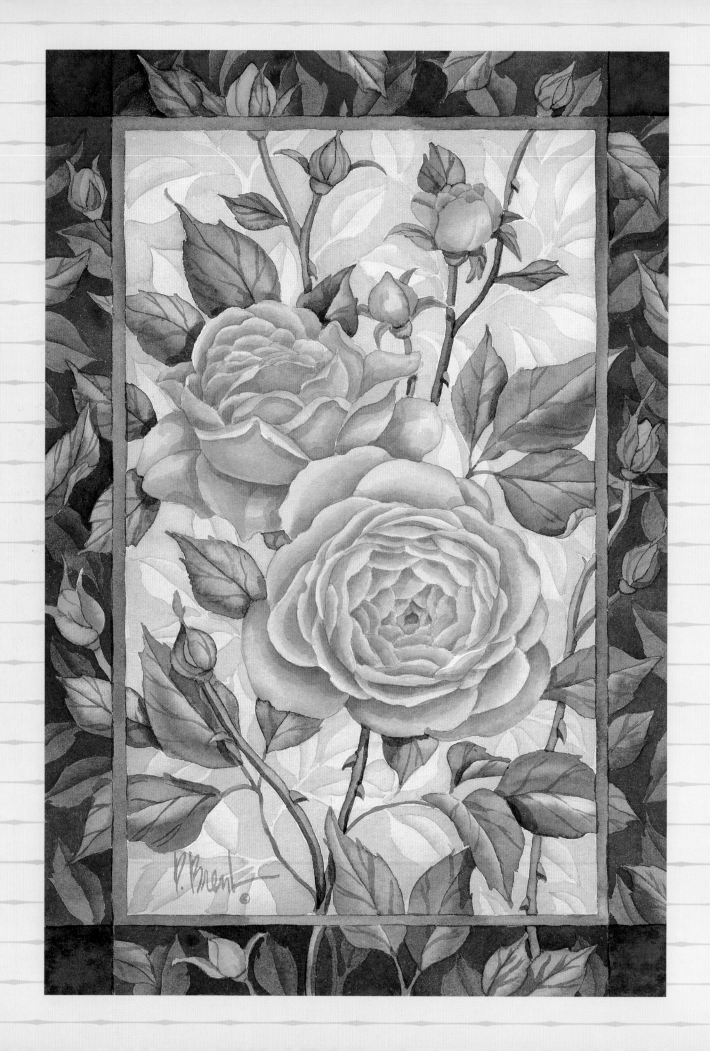

Cabbage Roses

◆ *From ancient China to the time of the*
Roman Empire to modern day America,
people have cultivated roses for their beauty,
variety of color and continuous blooming habits. One of the
hardiest varieties is the old-fashioned cabbage rose, which
was popular in the Victorian era and recently has been
revived from abandoned gardens and forgotten lanes.
The character of the multiple tight petals that form a
dense center is both a delight to the viewer and a challenge
to the artist. To successfully paint this flower, you must
pay attention to each petal as well as to the overall shape
of the blossom.

MATERIALS LIST

BRUSH
no. 3 round

PALETTE
Grumbacher or Winsor Red
Indian or Venetian Red
Mauve
Permanent Sap Green
Thalo or Winsor Green
Ultramarine Blue
Vermilion
Yellow Ochre

SURFACE
22" x 15" (56cm x 38cm)
 300-lb. (640gsm) cold-press
 watercolor paper

OTHER
black felt-tip pen
drafting tape
eraser
facial tissue
straight edge
tracing paper
2H lead pencil

Painting Background

1. UNDERPAINT BACKGROUND

Wash clear water over a segment of the background. While the area is still wet, paint around the edges of this area with a mixture of Yellow Ochre and Vermilion, allowing the color to bleed into the water. Blend the area with your brush to achieve a dark edge and a light center. Allow the area to dry.

2. DEFINE LEAF SHAPES

Lightly sketch the background leaf shapes. Paint around these shapes with a mixture of Yellow Ochre and Vermilion. Allow the area to dry completely.

3. ACCENT LEAVES

Paint a stroke above the center vein of each leaf with a mixture of Yellow Ochre and Vermilion. While the paint is still wet, clean your brush and lay a wash of clear water over the rest of the upper segment of the leaf, allowing the color to bleed into the water. Blot the outer edge of the leaf with a tissue to prevent a hard edge from forming.

◆ DEMO ◆

Painting Petals and Leaves

1. UNDERPAINT PETAL

Brush clear water over the entire surface of the petal. While still wet, paint a stroke of pale Grumbacher or Winsor Red on both the inner and outer edges of the petal, allowing the color to bleed toward the center. If it bleeds too much, lift some of the pigment with a clean brush to maintain the highlight. To give more color to the edges, drop extra paint onto the edges with the tip of your brush and let it bleed. Allow the petal to dry.

2. ADD SHADOW

Paint a shadow at the base of the petal with a pale wash of Mauve. Allow it to dry.

3. PAINT PETAL FOLD

Paint a stroke of Grumbacher or Winsor Red on the right side of the center of the petal. While it's still wet, clean your brush and then stroke clear water along the center of the petal next to the stroke of paint, allowing the color to bleed into the water. Blot the edge of the clear water with a tissue to prevent a hard edge from forming.

1. BEGIN LEAF

Paint the upper segment of the leaf with Permanent Sap Green. While the area is still wet, lift some pigment from the center. Allow the segment to dry.

2. UNDERPAINT REST OF LEAF

Lay a stroke of Permanent Sap Green along the outer edge of the lower segment. While it's still wet, clean your brush and apply clear water to the inner portion of the segment, allowing the color to bleed into the clear water. Dry your brush on a tissue and blend the area between the color and clear water.

3. PAINT VEINS

Paint the veins with a mixture of Permanent Sap Green and Thalo or Winsor Green. Begin each stroke at the center of the leaf, lifting the brush so the vein narrows toward the outer edge.

Cabbage Roses

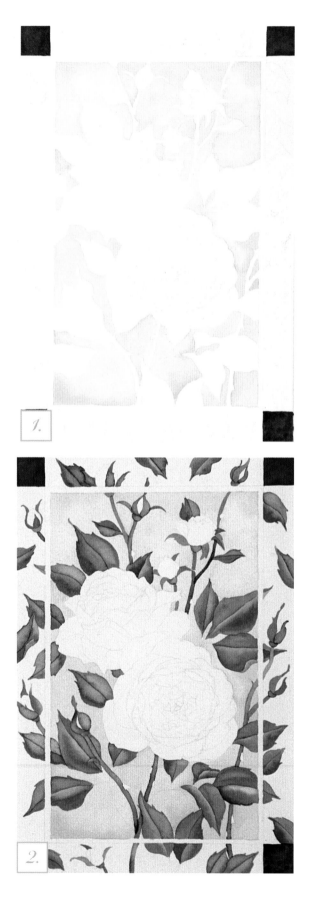

1. PREPARE BACKGROUND

Wash a piece of watercolor paper. Trace the base drawing onto tracing paper and then onto the watercolor paper. Tape the outer edges of the painting with drafting tape. Paint the corners of the border with a mixture of Vermilion and Mauve. While the area is still wet, drop in more Mauve around the edges of the square to give the area some variety and depth. Lay a wash of clear water over the center of each segment of the background. Then paint around the edge of each area with a mixture of Yellow Ochre and Vermilion, allowing the color to bleed into the center to give the background dimension and a glow.

2. PAINT LEAVES

Paint the upper segment of each leaf with Permanent Sap Green. While the paint is still wet, lift some of the pigment from the center. Once these areas have dried, paint the lower segment of each leaf by laying a stroke of Permanent Sap Green along the outside edge of the segment. Then lay a stroke of clear water next to the leaf's center vein and allow the color to bleed into the water. Clean your brush and dry it on a tissue, then blend the paint into the water. Also paint the buds with Permanent Sap Green.

Paint the stems of the roses with Permanent Sap Green, beginning at the bloom or bud. Gradually add Indian or Venetian Red to the mixture as you move down each stem. Lift pigment from the center of the stem by dragging a clean, dry brush along the length of the stem. Leave indentations in the stem for the thorns to keep the thorns from looking two-dimensional.

3. BEGIN PETALS

Apply a medium-value stroke of Grumbacher or Winsor Red at the base of the petal, or the closest visible part of the petal to the base of the bloom. Don't use a value that is too dark. While the paint is still wet, clean your brush and lay clear water over the rest of the petal to the outer edge. For the petals farther away from the center, place another stroke of Grumbacher or Winsor Red that has been thinned with water along the outer edge of the petal, allowing the color to bleed toward the center. If the color bleeds too much and doesn't leave enough of a highlight, clean your brush, dry it on a tissue and lift some color from the center. You don't have to apply a second stroke on the outside of the petal when painting those petals closer to the flower's center. Just leave these petals' outer edges light.

4. PAINT BORDER BACKGROUND

Finish painting the petals as you did in Step 3. Paint the background of the border with a mixture of Permanent Sap Green and Thalo or Winsor Green. Occasionally add some Indian or Venetian Red. Put the darkest value of the mixture closest to the leaves and buds, and leave the more open areas lighter.

5. ADD SHADOWS

Paint the thorns with a fairly red mixture of Indian or Venetian Red and Permanent Sap Green. Paint shadows under the overlapping and folded petals, especially toward the outside of each bloom, with a light mixture of Grumbacher or Winsor Red and Mauve. A dark value of this mixture would turn this rose from delicate pink to an unpleasant shade of red. Always start light; you can go back and add color if necessary.

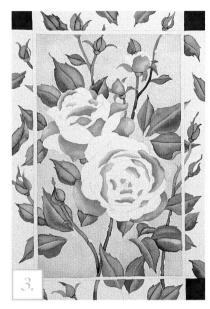

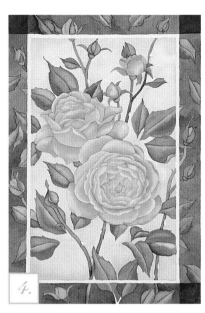

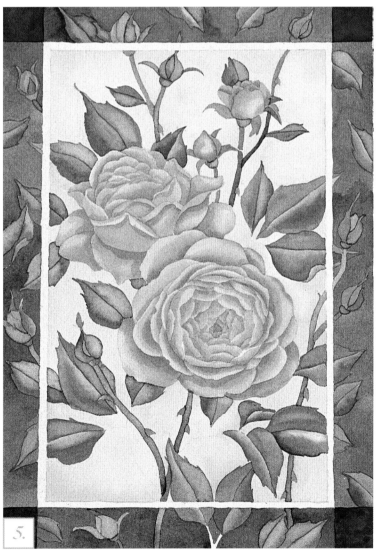

Cabbage Roses, *continued*

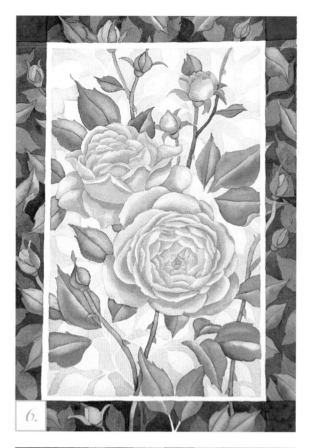

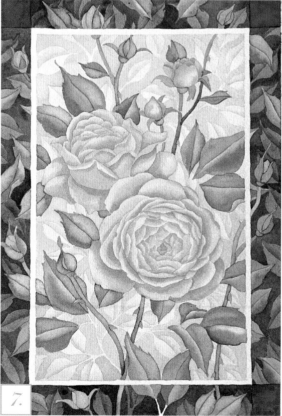

6. DEFINE BACKGROUND LEAVES

Lightly sketch the background leaves on the border and behind the roses. Paint around the border leaf shapes with a mixture of Permanent Sap Green and Thalo or Winsor Green. Paint around the leaf shapes behind the roses with a mixture of Yellow Ochre and Vermilion.

7. ACCENT BACKGROUND LEAVES

Paint a stroke just above the center vein of the border's background leaves with a mixture of Thalo or Winsor Green and Permanent Sap Green. While it's still wet, clean your brush and lay down a stroke of clear water just above your first stroke, allowing the color to bleed into the clear water. This shaded line adds detail and dimension to the leaves. Paint the leaves in the background behind the roses the same way with a mixture of Yellow Ochre and Vermilion.

8. ADD DETAILS

Paint veins on the foreground leaves in the center and the border with Thalo or Winsor Green. Paint the rest of the leaves' stems with a mixture of Permanent Sap Green and Indian or Venetian Red. Add a shadow beneath angled stems or on the right sides of upright stems with a mixture of Permanent Sap Green and Indian or Venetian Red. Paint the shadows that fall on the stems and leaves from other objects with Thalo or Winsor Green. Make the shadows under the rose petals deeper with a darker mixture of Grumbacher or Winsor Red and Mauve. Add some more dimension to the roses and buds by making some of the bases and edges of the petals darker with light washes of Grumbacher or Winsor Red. After each stroke of red, clean your brush and blend the color into the lighter area with clear water.

9. ADD FINAL TOUCHES

Add shadows under the thorns with a mixture of Indian or Venetian Red and Permanent Sap Green. Paint the thin border with Ultramarine Blue. Carefully remove the drafting tape and erase any pencil lines that remain.

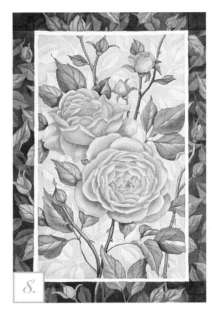

The important thing to remember when painting roses is to maintain the volume of the flower and not let the texture of the petals overwhelm the general rounded shape of each blossom. This was a subtle painting without as much contrast as some of the others, so it's important to keep each element distinct.

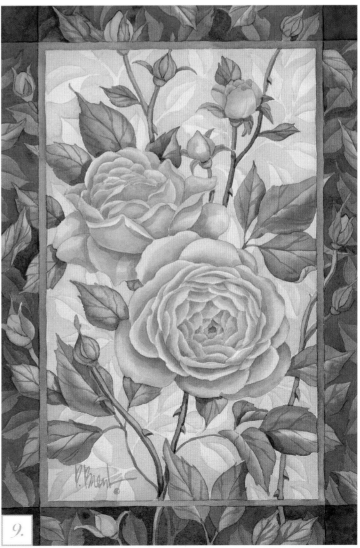

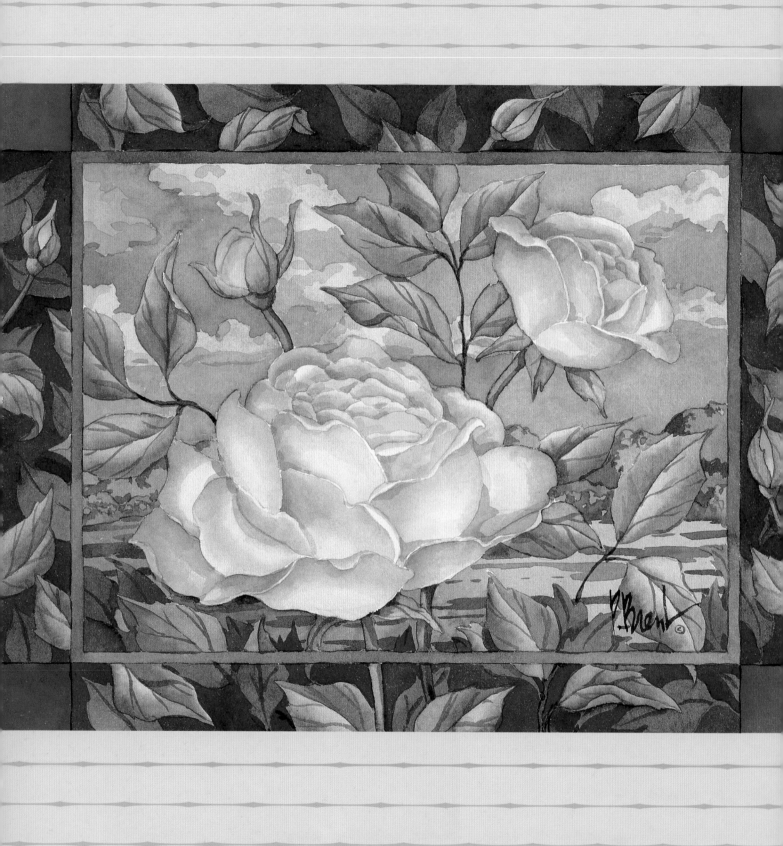

English Tea Roses

✦ *One of my favorite colors of a rose is a gentle pink that shades into yellow. This combination makes the rose look as if it has its own light source in the center of its bloom. This painting will show you how to achieve this lighting effect while capturing the sculptural effects of each petal.*

MATERIALS LIST

BRUSH
no. 3 round

PALETTE
Cadmium Yellow Deep
Cerulean Blue
Grumbacher or Winsor Red
Indian or Venetian Red
Mauve
Permanent Sap Green
Thalo or Winsor Crimson
Thalo or Winsor Green
Ultramarine Blue

SURFACE
15" x 22" (38cm x 56cm)
 300-lb. (640gsm) cold-press
 watercolor paper

OTHER
black felt-tip pen
drafting tape
eraser
facial tissue
straight edge
2H lead pencil

Painting Background

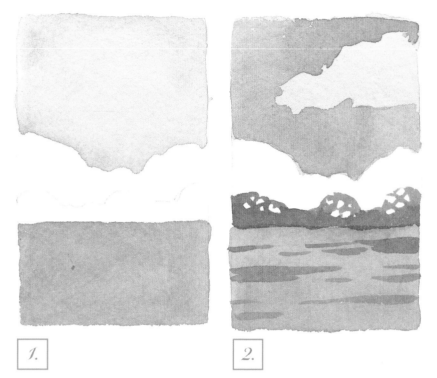

1.

2.

1. UNDERPAINT SKY AND GRASS

Paint the sky with a pale value of Cerulean Blue. Paint the grass with a light value of Permanent Sap Green. Allow these areas to dry.

2. DEFINE CLOUD SHAPE

Lightly sketch the cloud. Paint the sky around the cloud with a mixture of Cerulean Blue and Mauve. Paint the shadows on the grass with a mixture of Permanent Sap Green and Thalo or Winsor Green. Paint the rose bushes with the same mixture, leaving some spaces white where you'll paint roses in Step 2. Allow these areas to dry.

3. ADD DETAILS

Paint the tree line with a mixture of Thalo or Winsor Green and Cerulean Blue. Paint the roses with a pale value of Grumbacher or Winsor Red. Paint the shadows on the clouds with a mixture of Cerulean Blue and Mauve. Allow these areas to dry. Then paint shadows on the tree line with a darker mixture of Thalo or Winsor Green, Cerulean Blue and Indian or Venetian Red, placing them as if the light source is shining from above and to the right.

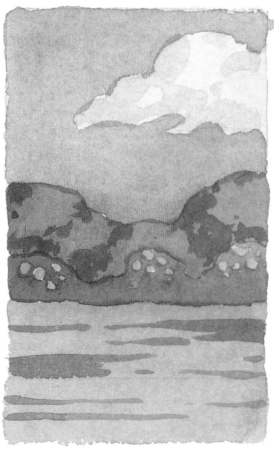

3.

✦ DEMO ✦
Painting Petals

1. BEGIN PETAL

Wash the underside of the petal, but not the fold, with clear water. While the area is still wet, paint a stroke of Cadmium Yellow Deep along the base of the petal, allowing the color to bleed into the water. Use a tissue to blot the upper edge of the wet area to control the bleed. Allow the area to dry.

2. ADD PINK

Wash the same area with clear water. While it's still wet, paint the upper edge of the underside of the petal with a pale value of Grumbacher or Winsor Red. Extend the stroke down the edges of the petal until the color begins to blend into the yellow area. Allow the red to bleed into the clear water. Again control the bleed by blotting with a tissue. Let the paint dry.

3. PAINT FOLD

Paint the upper edge of the fold at the top of the petal with a light value of Grumbacher or Winsor Red. While it's still wet, clean your brush and wash the rest of the fold with clear water, allowing the color to bleed into the water. Blot the lower edge of the fold with a tissue to control the bleed. Allow the area to dry.

4. ADD SHADOW

Paint a shadow under the fold with a single stroke of a light value of Mauve. Allow the paint to dry. Paint a single stroke of pale Grumbacher or Winsor Red up the center of the petal. While it's still wet, clean your brush and wash the right side of the petal with clear water so the stroke of color bleeds just a bit. Blot with a tissue if necessary.

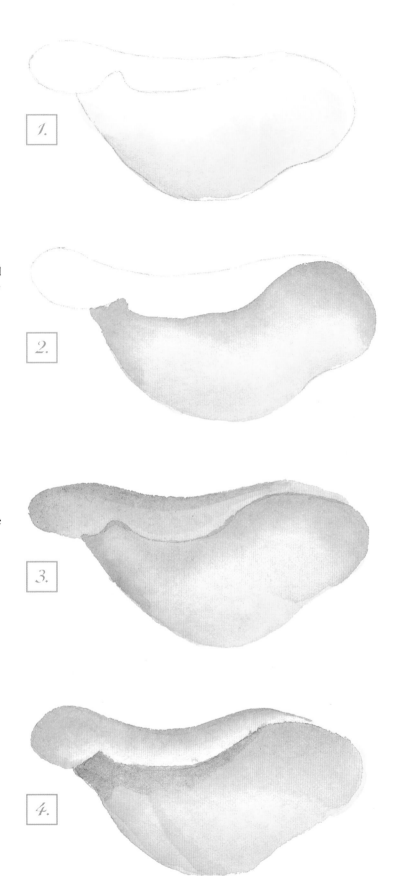

English Tea Roses

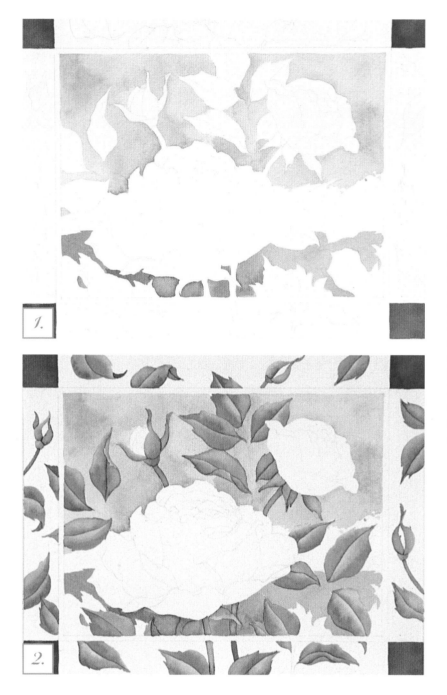

1.

2.

1. PREPARE BACKGROUND

Trace the drawing onto watercolor paper and tape the edges with drafting tape as usual. Paint the corners of the border with a mixture of Thalo or Winsor Crimson and Mauve. Drop extra color on the corners with the tip of your brush to vary the color. Paint the sky with Cerulean Blue. Use a light value; you'll add more layers later when you define the cloud shapes in the background. Paint the grass background with Permanent Sap Green.

2. PAINT LEAVES

Paint the upper segment of each leaf with Permanent Sap Green. While the paint is still wet, lift some pigment from the center of each segment. Let the leaves dry. Lay a stroke of clear water just below the center vein of the leaf. While that is still wet, lay a stroke of Permanent Sap Green on the outer edge of the lower leaf segment. Extend the stroke of color to the edges of the water and allow the color to bleed into the water. Clean your brush, dry it on a tissue and blend the area between the water and the color. Paint the stems with Permanent Sap Green. Lift some pigment from the centers of the stems by dragging a clean, dry brush along each stem while it's still wet. Remember to allow each area to dry before painting an adjacent area.

3. BEGIN PETALS

Paint the background of the border with a mixture of Permanent Sap Green, Thalo or Winsor Green and Indian or Venetian Red. Vary the color and value of the mixture as you paint. Lay a wide stroke of clear water over each petal. While this is still wet, lay a wash of a light mixture of Cadmium Yellow Deep over the petal from the base up to the water. Allow the color to bleed into the water. If the color bleeds too far, blot the area with a tissue. Allow the petals to dry. You don't have to paint the yellow blush on every petal. Add it just to those petals for which the base is visible.

4. ADD PINK

To paint the outermost petals, lay a wash of clear water over the yellow part that has already dried. Lay down a stroke of a light mixture of Grumbacher or Winsor Red, extending it to meet the edges of the clear water. Allow the color to bleed into the clear water. If it bleeds too far, blot the damp area with a tissue. Remember to let each petal dry before painting one next to it. On the inner petals, stroke clear water on the upper edges. While this is still wet, lay down a light mixture of Grumbacher or Winsor Red from the part of the petal closest to the flower's base up to the water, allowing the color to bleed into the water. Blot excess color with a tissue or lift the pigment with a clean, dry brush to keep the edges light. Allow the petals to dry.

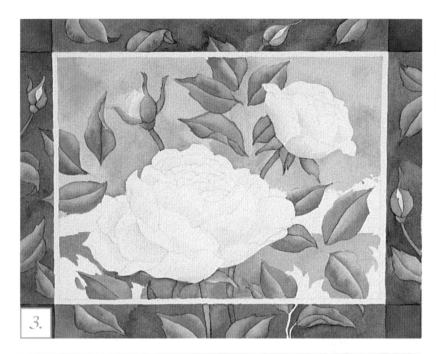

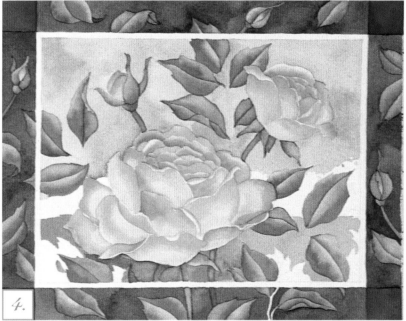

English Tea Roses, *continued*

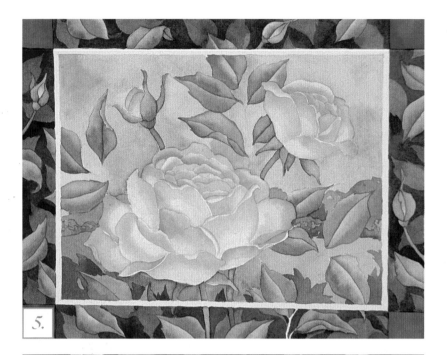

5.

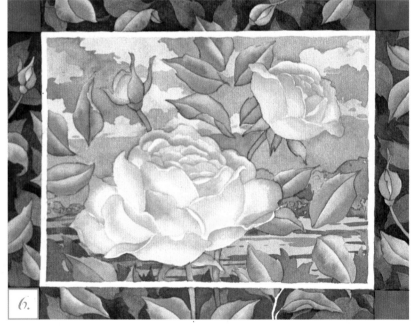

6.

5. UNDERPAINT BACKGROUND

Paint the tree line in the background with a mixture of Thalo or Winsor Green and Cerulean Blue. Paint the rose bushes with a mixture of Permanent Sap Green and Thalo or Winsor Green, leaving spaces for the rose blossoms. Let the bushes dry and then paint the pink blossoms with light Grumbacher or Winsor Red. Sketch the leaf shapes over the border background. Paint around these shapes with a mixture of Thalo or Winsor Green and Permanent Sap Green. Fill in the leaves below the larger rose with the same mixture.

6. ADD DETAILS TO BACKGROUND

Lightly sketch the cloud shapes over the sky and the shadow lines over the grass. Paint the sky around the clouds with a mixture of Cerulean Blue and Mauve. Paint the shadows with a mixture of Permanent Sap Green and Thalo or Winsor Green. Vary the value of the mixture as you paint different shadows.

The most important lesson from this painting is learning to create that golden glow at the base of each petal. You can learn more about that from looking at an actual rose than from me telling you how to achieve the effect. Remember to keep observing and studying the wonders of nature.

7. ADD FINAL TOUCHES

Paint the leaf stems and leaf veins with a mixture of Indian or Venetian Red and Permanent Sap Green. Add shadows to the tree line with a mixture of Thalo or Winsor Green, Cerulean Blue and Indian or Venetian Red. Add a few shadows to the rose petals with a mixture of Grumbacher or Winsor Red and Mauve. Remember to keep the shadows light. Add shadows to the clouds with a mixture of Cerulean Blue and Mauve. Paint the thin border with Ultramarine Blue. Carefully remove the drafting tape and erase any pencil lines that remain.

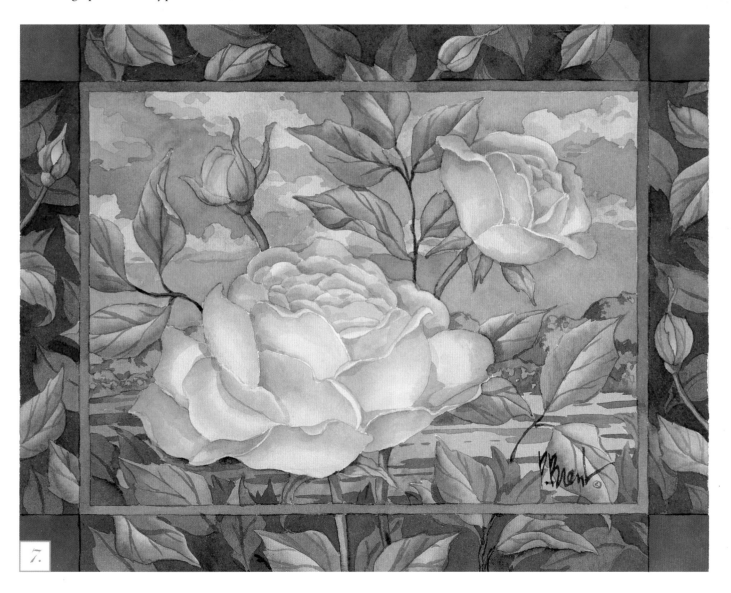

7.

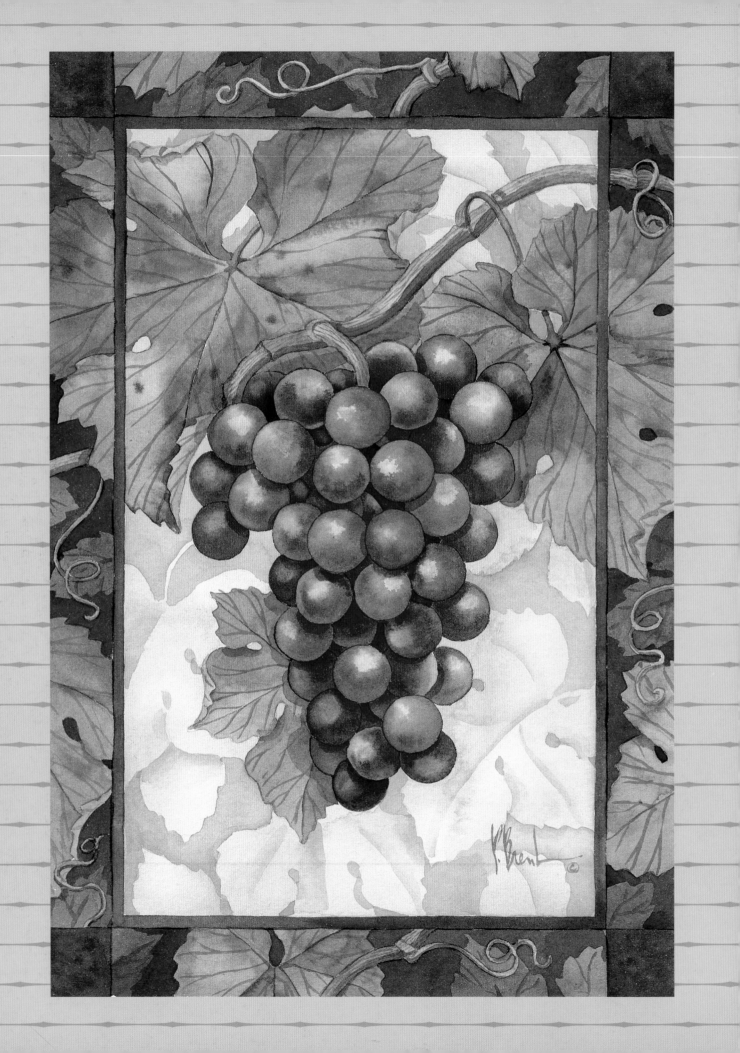

Vineyard Grapes

♦ *The magnificent beauty of ripe grapes on the vine is hard to match. Each grape has a subtle variety of color and shape, and the jagged edge of the leaves forms a perfect foil to the smooth roundness of the grapes themselves. The painting's color scheme at first seems to be limited to purple and green, but upon closer inspection, you'll find that the purple grapes move from reds to blues and the green from forest green to gold and brown.*

♦ MATERIALS LIST

BRUSH
no. 3 round

PALETTE
Indian or Venetian Red
Mauve
Permanent Sap Green
Thalo Crimson
Thalo or Winsor Green
Ultramarine Blue
Vermilion
Yellow Ochre

SURFACE
20" x 15" (51cm x 38cm)
 300-lb. (640gsm) cold-press
 watercolor paper

OTHER
black felt-tip pen
cotton swabs
drafting tape
eraser
facial tissue
straight edge
2H lead pencil

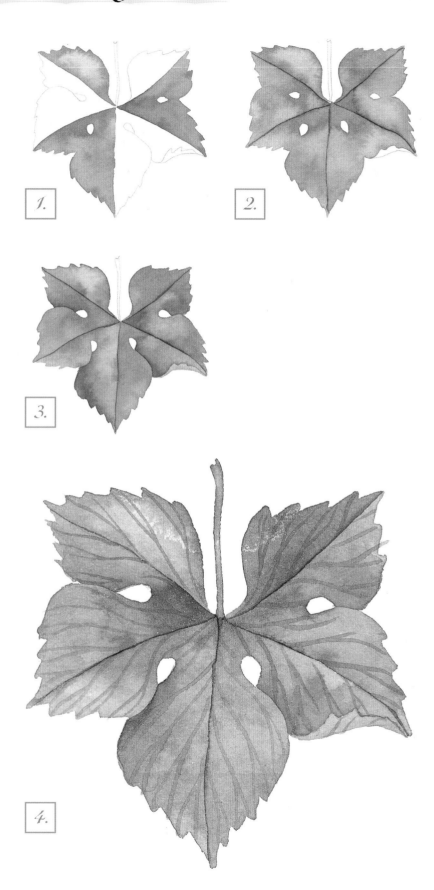

1. BEGIN LEAF

Paint alternating segments of the leaf with a mixture of Permanent Sap Green and Yellow Ochre. Vary the amounts of color with each stroke to give the leaf a lot of variety of color. While the paint is still wet, clean your brush and drop in some dots of Indian or Venetian Red, making sure to place some next to the veins. Allow the colors to bleed into each other and dry.

2. PAINT REMAINING SEGMENTS

Paint the rest of the leaves as described in Step 1, allowing a hard edge to form along the veins. Don't get carried away with dropping in Indian or Venetian Red. A few drops will give that aged look without detracting from the overall painting.

3. DEFINE SEGMENTS

Paint the shadows where the leaves overlap with a stroke of Permanent Sap Green under the overlapping leaf's edge. Clean your brush and blend the stroke into the leaf with clear water. Blot the edge of the clear water with a tissue to prevent a hard line from forming. Paint the turned edge of the leaf with Yellow Ochre. While the paint is still wet, paint a thin line of Permanent Sap Green along the outer edge, allowing the green to bleed into the yellow.

4. PAINT VEINS

Paint the veins with Permanent Sap Green, beginning each stroke at the base of the center vein. Position the painting so you can pull the vein to the edge of the leaf. Lift the brush as you go so the vein tapers toward the edge of the leaf.

◆ DEMO ◆
Painting Grapes and Stems

1. UNDERPAINT GRAPE

Wash clear water over one grape. Lay a wash of Mauve inside the edge of the grape and allow the color to bleed toward the highlight area in the upper left. While the paint is still wet, add some Magenta just inside the lower edge of the grape with either a light stroke or a series of small dots from the tip of your brush. Allow the Magenta to bleed into the Mauve. Quickly dab the center of the highlight area with a cotton swab to keep the paper as light as possible. Remember to use a clean cotton swab each time and dab lightly. Allow the grape to dry.

2. PAINT REMAINING GRAPES

Paint the rest of the grapes the same way. After adding Mauve around the edge of an overlapped grape and letting the color bleed, apply a stroke of a mixture of Ultramarine Blue and Mauve under the overlapping grape. Then add the Magenta as described in Step 1. Allow the colors to bleed into the Mauve and then dab the highlight with a cotton swab. Allow the grapes to dry. The extra color on the overlapped grapes helps define each grape's shape.

3. ADD SHADOWS

Add shadows that fall from the overlapping grapes with a mixture of Ultramarine Blue and Mauve.

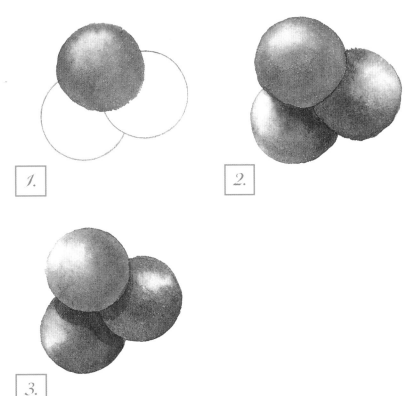

1.

2.

3.

1. UNDERPAINT STEM

Paint non-adjacent segments of the stem with a mixture of Indian or Venetian Red and Permanent Sap Green. Vary the mixture so the main stem is more brown and the areas closer to the leaves and grapes are greener. While each area is still wet, clean your brush and stroke along the center of the stem to lift some color to create a highlight.

2. PAINT JOINTS

Paint the rest of the stem and the joints the same way.

3. PAINT DETAILS

Paint a shadow along the lower edge of the stem with a mixture of Indian or Venetian Red and Permanent Sap Green. Then use a series of short strokes with the same mixture to create texture.

1.

2.

3.

Vineyard Grapes

1.

1. PAINT BACKGROUND

Wash the watercolor paper with clear water. When it's dry, trace the drawing onto the watercolor paper. Use a straight edge to draw the borders, and frame the outside edge with drafting tape. Wash clear water over the background areas and then paint around the edges of these areas with a mixture of Yellow Ochre and Vermilion. Allow the color to bleed into the wet area. While the background is still wet, brush some of the color across the lighter areas to give variety to the background. Paint the corners of the border with Mauve. Drop Indian or Venetian Red into the corners while still wet for variety.

2. PAINT LEAVES

Paint alternating segments of the leaves with a mixture of Permanent Sap Green and Yellow Ochre. While the segments are still wet, drop spots of Indian or Venetian Red close to the veins and scatter additional spots around the center of each leaf segment. Once these dry, paint the rest of the leaf segments in the same manner.

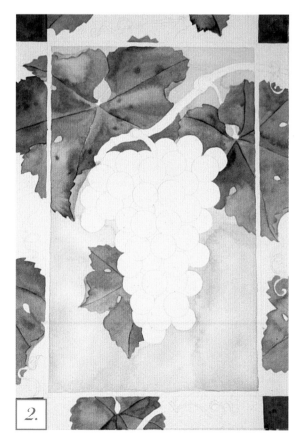

2.

3. PAINT GRAPE VINES

Paint the wide stem segments with Indian or Venetian Red. While each segment is still wet, stroke the center of the stem with clear water. Allow each segment to dry before painting an adjacent one. Paint the stem joints, leaf stems and tendrils with a mixture of Permanent Sap Green and Indian or Venetian Red. Use more green in the mixture closer to the leaves and grapes.

4. BEGIN GRAPES

Paint the grapes that don't touch each other by brushing a wash of clear water over the major part of each grape. Paint around the outside of each grape with Mauve, allowing the paint to bleed into the center. While the paint is still wet, apply Thalo Crimson just inside the lower edge of the grape with a series of tiny dots in a curving line. Allow the Thalo Crimson to bleed into the Mauve. Add Ultramarine Blue to shadow areas, dropping the color along the shadow edge. Quickly dab the spot where there should be a highlight with a cotton swab. Use a clean cotton swab for each grape, and dab lightly. Allow each grape to dry before painting an adjacent grape. Paint the background of the border with an even wash of Permanent Sap Green and Thalo or Winsor Green.

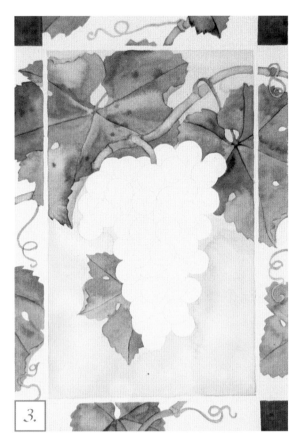

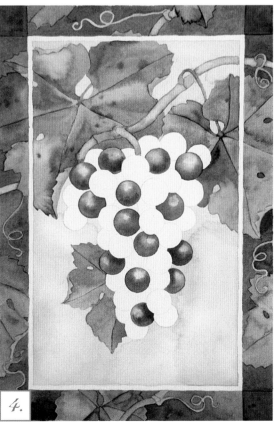

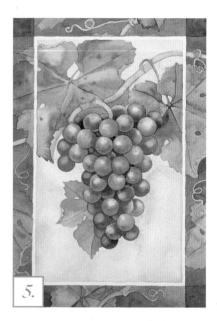

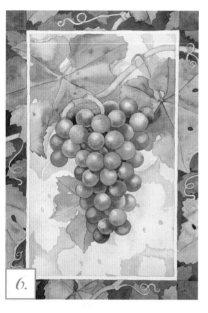

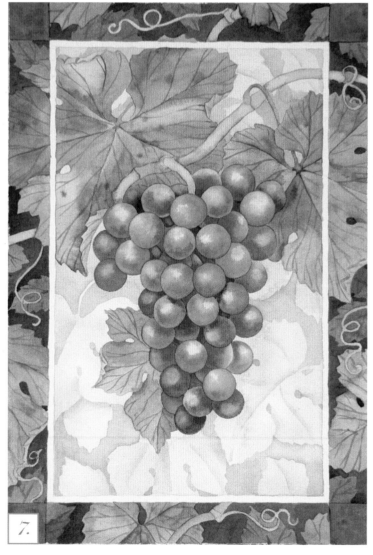

5. COMPLETE GRAPES

Finish the rest of the grapes, letting each one dry before painting one next to it. Each grape will vary in color because the Mauve, Thalo Crimson and Ultramarine Blue will take different proportions in each one. This will make some appear riper than others, as in real life.

6. PAINT BACKGROUND LEAVES

Sketch additional leaves in the border, and paint around them with a mixture of Thalo or Winsor Green and Permanent Sap Green. Sketch in leaf shapes behind the grapes and grape leaves. Lay a fairly consistent wash around the new leaf shapes with a mixture of Yellow Ochre and Vermilion.

7. PAINT LEAF VEINS

Where leaves overlap, paint around the edge of the lower leaf with Permanent Sap Green. Blend the stroke into the rest of the leaf with clear water, and then blot the edge of the clear water with a tissue to prevent a hard edge from forming. Paint the veins of the green leaves with Permanent Sap Green, beginning each stroke at the base of the vein. Position the painting so you can pull the vein toward you. Lift the brush as you go so the vein tapers toward the edge of the leaf. Paint the veins of the ochre background leaves with a mixture of Yellow Ochre and Vermilion. While the paint is still wet, apply a stroke of clear water next to the initial stroke and allow the color to bleed toward the edge of the leaf. Then blot the edge with a tissue to prevent a hard line from forming.

8. ADD SHADOWS

Lightly sketch areas of shadow on the grapes and leaves. Paint the shadows on the grapes with a mixture of Mauve and Ultramarine Blue. Paint the shadows on the leaves with a mixture of Permanent Sap Green and Mauve. Paint a shadow line on the stems and tendrils with a mixture of Indian or Venetian Red and Permanent Sap Green. Add texture to the stems with very fine lines of Indian or Venetian Red following the direction of the stems. Paint the inner border with a mixture of Mauve and Indian or Venetian Red. Remove the drafting tape and erase any pencil lines that still show.

Practice removing paint with cotton swabs so you can achieve a consistent effect. This technique will come in handy in many other watercolor projects. You can use it to make highlights when painting metal and ceramic subjects and to add texture.

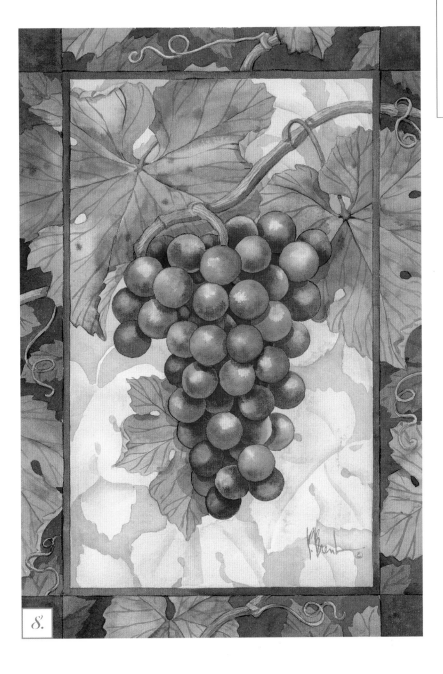

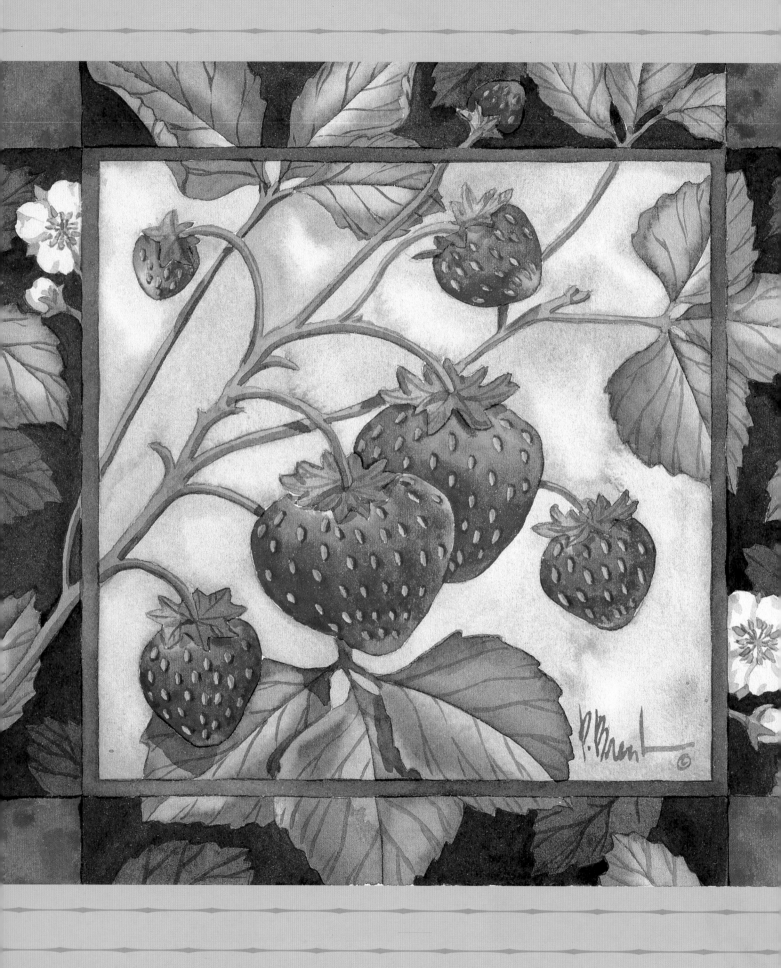

9

Scarlet Strawberries

✦ *One of the most beloved fruits of summer is*

the strawberry. Its bright color and unique taste make it

a favorite for pies, shortcake and, maybe best of all, dipping

in dark chocolate. Capturing this treat in watercolor requires

planning and attention to detail. You'll learn to use a liquid

masking fluid to save areas of the original white paper while

flooding the surrounding areas with color.

MATERIALS LIST

BRUSHES
no. 3 round
no. 0 or 00 round

PALETTE
Cadmium Yellow Deep
Cerulean Blue
Grumbacher or Winsor Red
Mauve
Permanent Sap Green
Thalo or Winsor Green
Ultramarine Blue
Vermilion
Yellow Ochre

SURFACE
15" x 15" (38cm x 38cm)
 300-lb. (640gsm) cold-press
 watercolor paper

OTHER
black felt-tip pen
drafting tape
facial tissue
masking fluid
soft white eraser
straight edge
2H lead pencil

Painting Blossoms

1.

2.

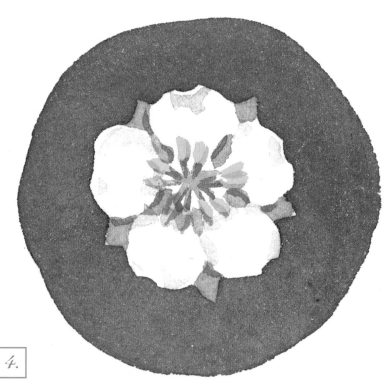

3.

1. **PAINT BACKGROUND**

Paint around the shape of the flower with the painting's background color, Permanent Sap Green. Allow the paint to dry.

2. **ADD DIMENSION**

Paint the spaces between the petals and the tiny leaves around the flower with a lighter value of Permanent Sap Green. Paint the shadows on the petals with a mixture of Cerulean Blue and Mauve. Allow the paint to dry.

3. **ADD DETAILS**

Paint the anthers, the yellow parts of the centers, with Cadmium Yellow Deep. Allow the paint to dry. Paint the stalks that support the anthers with Permanent Sap Green and allow the paint to dry.

4. **PAINT SHADOWS**

Add shadows on the lower or right side of each anther with a thin stroke of Yellow Ochre. Allow the paint to dry. Add shadows on the stalks and beneath the petals with thin strokes of Permanent Sap Green.

4.

◆ DEMO ◆
Painting Strawberries

1. MASK SEEDS

Cover the seeds with a liquid mask, such as Winsor & Newton Art Masking Fluid, and a no. 0 or no. 00 round brush. Use an old brush because liquid mask will make good brushes unsuitable for painting with watercolors. Let the mask dry thoroughly.

2. UNDERPAINT STRAWBERRY

Wash the strawberry with clear water using a no. 3 round brush. Begin at the upper left side of the strawberry, paint the left edge, then the center and then the right edge with Grumbacher or Winsor Red. Don't apply paint directly to the very top or the bottom tip of the strawberry; allow the paint to bleed into these areas instead. While the paint is still wet, lay a very thin stroke of Grumbacher or Winsor Red along the bottom of the tip and allow it to bleed into the lighter area. Also, stroke the right side of each seed with Grumbacher or Winsor Red to create the shadows that will be cast by the side. Allow the strawberry to dry.

3. PAINT SEEDS

Remove the liquid mask with a soft white eraser. These areas will show the white of the paper. Paint the seeds with Cadmium Yellow Deep. Paint the green top of the strawberry with Permanent Sap Green. While this area is still wet, blot the left edge with a tissue to lighten it.

4. ADD DETAILS

Paint a shadow on each seed with a thin stroke of Yellow Ochre. Allow the paint to dry and then paint another thin stroke of Grumbacher or Winsor Red on the right side of each seed to give a sharp shadow. Paint the shadows under the green top with a light wash of Grumbacher or Winsor Red. Let the paint dry. Paint veins and define the stem of the strawberry with Permanent Sap Green. Paint shadows along the lower edges of the green top with Permanent Sap Green.

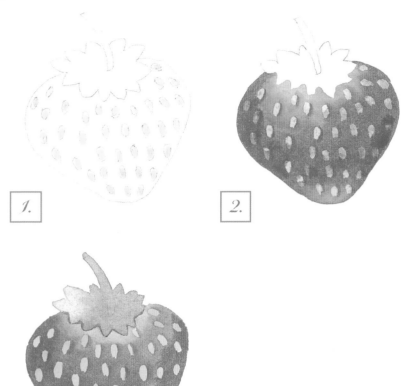

1. *2.*

3.

4.

Scarlet Strawberries

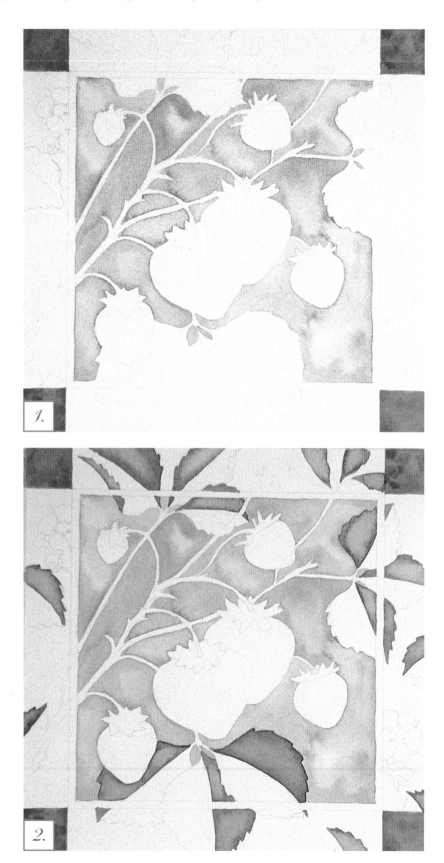

1. PAINT BACKGROUND

Trace the drawing onto a piece of watercolor paper. Use a straight edge to draw the borders, and frame the outside edges of the painting with drafting tape. Paint the corners with Vermilion. While the paint is still wet, drop in Grumbacher or Winsor Red with the tip of your brush, allowing it to bleed into the Vermilion. Wash a segment of the background with clear water and then paint around the edges of the segment with Cerulean Blue, allowing the paint to bleed toward the center. Paint the rest of the background in similar segments.

2. BEGIN LEAVES

After the background has dried, paint the upper half of each leaf with Permanent Sap Green. While the paint is still wet, clean your brush and apply a stroke of clear water in the middle of the segment to float some color to the edges and to lift some color to form a highlight.

3. FINISH GREENERY

Paint the lower halves of the leaves with Permanent Sap Green. Clean your brush and lift color along the center vein. Paint the green area at the top of each strawberry with Permanent Sap Green. While the paint is still wet, blot the left edge with a tissue to form a highlight. Paint the background of the border with a mixture of Permanent Sap Green and Thalo or Winsor Green.

4. PAINT STEMS AND PETALS

Paint the stems with Permanent Sap Green. While the paint is still wet, clean your brush and lightly stroke the center of each stem to lighten it and add some volume. Paint the shadows created by the folds in the flower petals with a very light mixture of Cerulean Blue and Mauve. Paint the small leaves that surround each flower with Permanent Sap Green.

3.

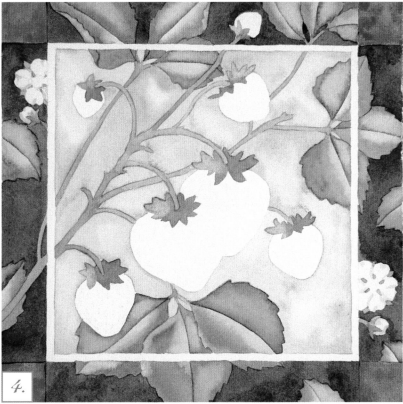

4.

Scarlet Strawberries, continued

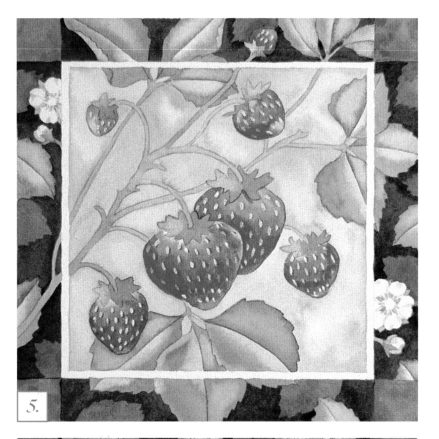

5.

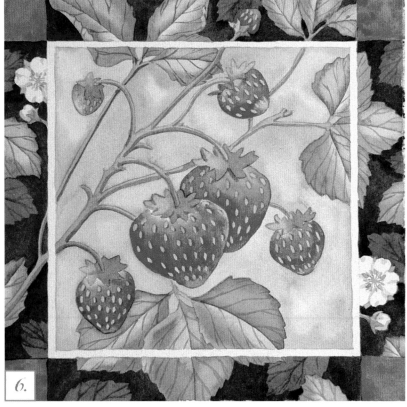

6.

5. PAINT STRAWBERRIES

Cover the seeds on the strawberries with a liquid mask using a very small brush, such as a no. o or no. oo round brush. Use an old brush if possible; the mask will dry on your brush, making it unusable for watercolor painting. After the mask has dried, load a no. 3 round brush with Grumbacher or Winsor Red and paint each strawberry, beginning on the upper left edge and stroking down. Then paint the center and then the right side of each berry, allowing the color to bleed into the top and the bottom tips of the berries.

For the two strawberries that overlap, keep the upper right edge of the front berry light so it will stand out from the other. While the paint is still wet, add a very thin stroke of Grumbacher or Winsor Red around the tip of each strawberry and a deeper stroke around the right edge of each seed. This will add dimension by setting the seeds in small pockets. Allow these strokes to bleed into the adjacent areas. When the paint has dried, paint the blossom anthers with Cadmium Yellow Deep. Sketch leaf shapes in the background of the border and paint around these shapes with a mixture of Permanent Sap Green and Thalo or Winsor Green.

6. BEGIN DETAIL

Remove the mask by lightly rubbing your eraser over the dried masking fluid. The dried mask should lift off easily, leaving white spots. Paint these spots with Cadmium Yellow Deep. Add veins to the leaves with Permanent Sap Green, beginning at the center vein and pulling the stroke to the edge of the leaf. Position the painting so you bring the stroke to the edge of the leaf as you paint. Lift the brush slightly as you go so the stroke tapers toward the edge of the leaf. Paint the stalks of the flower stamens with Permanent Sap Green. Add shadows to the stems with a mixture of Permanent Sap Green and Thalo or Winsor Green.

7. FINISH DETAIL

Add veins to the green tops of the strawberries and add shadows to the leaves with a mixture of Permanent Sap Green and Thalo or Winsor Green. Add a shadow on the right side of each seed with Yellow Ochre and let these areas dry. Then add a darker stroke on the right side of each seed with Grumbacher or Winsor Red. Paint shadows on each of the yellow anthers on the flowers with Yellow Ochre.

8. ADD SHADOWS

Add the shadows cast on the berries from the green tops with a mixture of Grumbacher or Winsor Red and Mauve. Paint the blue border with Ultramarine Blue. After the painting is dry, remove the drafting tape and erase pencil lines.

You may have noticed that I use a lot of the paints directly from the tube without mixing them with other colors, especially in this painting. This method results in the brightest hues you can get when painting in watercolor. To adjust the hue a bit but maintain the brightness, mix it with a color that is adjacent to the original color on the color wheel. In this painting I mixed Permanent Sap Green with Thalo Green. Other times I've added Indian Red or Payne's Gray to Permanent Sap Green to make it a bit more dull.

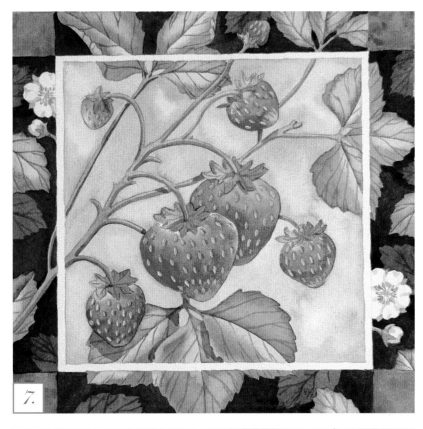

7.

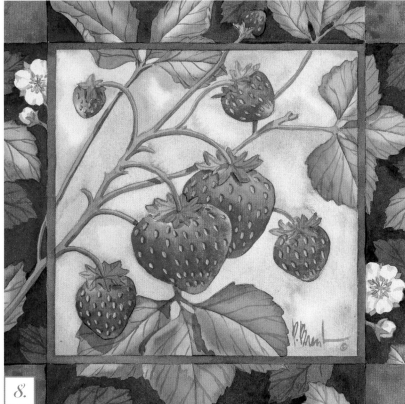

8.

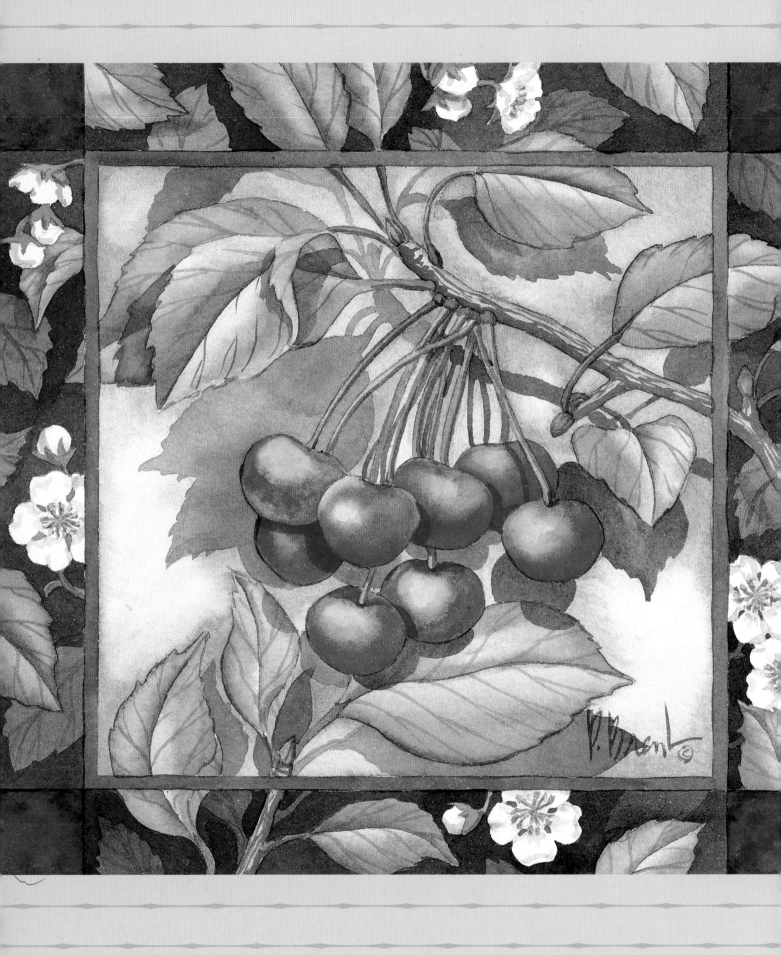

Florence Cherries

◆ *What could be more enticing than bright red cherries hanging from a branch?* It's a treat even George Washington couldn't resist. I chose to create a subdued green color scheme to make the red of the cherries even more vivid.

MATERIALS LIST

BRUSH
no. 3 round

PALETTE
Cadmium Yellow Deep
Cerulean Blue
Grumbacher or Winsor Red
Indian or Venetian Red
Mauve
Payne's Gray
Permanent Sap Green
Vermilion
Yellow Ochre

SURFACE
15" x 15" (38cm x 38cm)
 300-lb. (640gsm) cold-press
 watercolor paper

OTHER
black felt-tip pen
cotton swabs
drafting tape
fine black eraser
straight edge
2H lead pencil

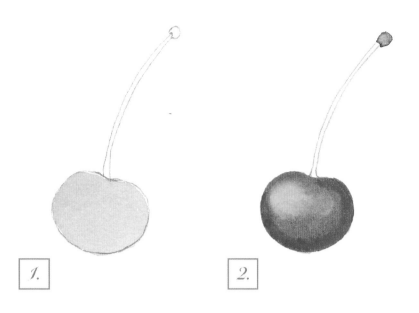

1.

2.

1. UNDERPAINT CHERRY

Cover the cherry with a pale wash of Cadmium Yellow Deep. Allow the paint to dry.

2. ADD RED

Cover the cherry with clear water. Paint around the edge of the cherry with a mixture of Grumbacher or Winsor Red and Vermilion, allowing the paint to bleed toward the highlight area in the upper left. Gently dab the highlight area with a cotton swab. Paint the small tip of the stem with Indian or Venetian Red. While the paint is still wet, clean your brush and lift some color from the center of the tip. Allow the paint to dry.

3. PAINT STEM

Paint the stem with a mixture of Permanent Sap Green and Indian or Venetian Red. While the paint is still wet, clean your brush and stroke down the center to lift some of the pigment. Allow the paint to dry.

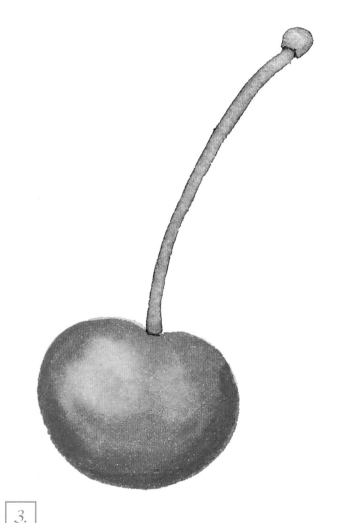

3.

✦ DEMO ✦
Painting Leaves and *Shadows*

1. BEGIN LEAF

Paint the left side of the leaf with Permanent Sap Green. While the paint is still wet, clean your brush and lift some of the pigment from the center to create a highlight. Stroke Payne's Gray along the center vein and allow it to bleed into the leaf. Allow the paint to dry.

2. FINISH UNDERPAINTING

Paint the other half of the leaf with Permanent Sap Green. While the paint is still wet, clean your brush and lift some color along the center vein to create a highlight. Allow the paint to dry.

3. ADD VEINS AND SHADING

Paint the veins with Permanent Sap Green. Position the painting so you can pull your strokes toward yourself. Begin each stroke at the center vein and taper the stroke toward the edge of the leaf.

1. OUTLINE SHADOW

Determine the direction of the light source and draw the outline of the shadow the leaves would cast. In this case, my light source is coming from the upper left.

2. PAINT SHADOW

Paint the shadow using Payne's Gray with your no. 3 round sable brush. Keep the tone next to the leaf darker and make it lighter further away from the leaf.

3. LOWER SHADOW

Draw the shadow on the lower leaf. This will always be disconnected from the lower shadow since the leaf surface is closer to the upper leaf than it is to the background surface. Paint the shadow on the leaf with Payne's Gray.

Florence Cherries

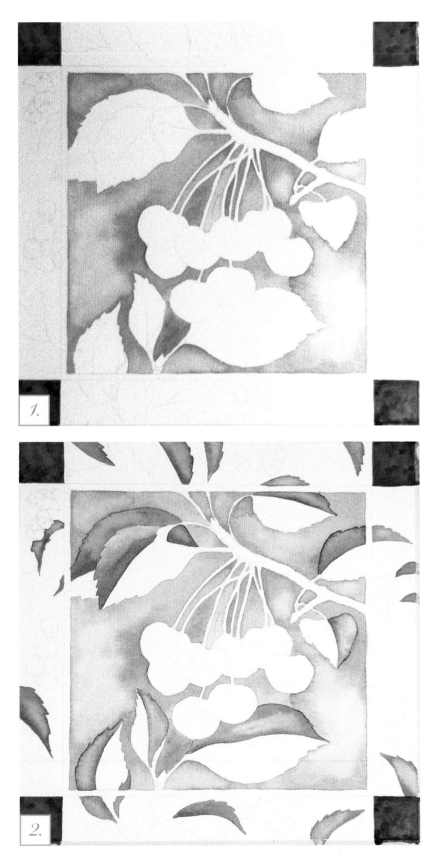

1. **PAINT BACKGROUND**

Trace the drawing onto watercolor paper and frame the outside edges with drafting tape. Paint a clear wash of water over a segment of the background. Paint around the edges of the segment with a mixture of Permanent Sap Green and Payne's Gray, allowing the color to bleed into the wet area. Paint the rest of the background in segments like this. Paint the corner squares with a mixture of Mauve and Grumbacher or Winsor Red. While the paint is still wet, drop more Mauve into the corners to create variety.

2. **BEGIN LEAVES**

Paint the upper halves of the leaves with Permanent Sap Green. While the paint is still wet, clean your brush and place a stroke of clear water down the center of the leaf segment. Then stroke a mixture of Permanent Sap Green and Payne's Gray along the center vein of the leaf for added dimension, allowing the paint to bleed into the painted area. Allow each leaf to dry before painting an adjacent area.

3. BEGIN CHERRIES

Paint the lower halves of the leaves with Permanent Sap Green. While the paint is still wet, clean your brush and place a stroke along the center vein to lift paint and create a highlight that gives form to the leaf. Paint an undercoat of Cadmium Yellow Deep over the cherries. Paint the branches with Indian or Venetian Red. While the paint is still wet, clean your brush and stroke along the center of the branch to lift some pigment.

4. CONTINUE CHERRIES

Paint each cherry separately. Cover a cherry with clear water and then paint around the outer edge with a mixture of Grumbacher or Winsor Red and Vermilion, allowing the color to bleed into the center. Dab the highlight area at the upper left of the cherry with a cotton swab. In areas where cherries overlap, make the overlapping edge of the closest cherry lighter and darken the color at the edge that is being overlapped. Paint the background of the border with a mixture of Permanent Sap Green and Payne's Gray. Vary the color and intensity a bit to give the border some life.

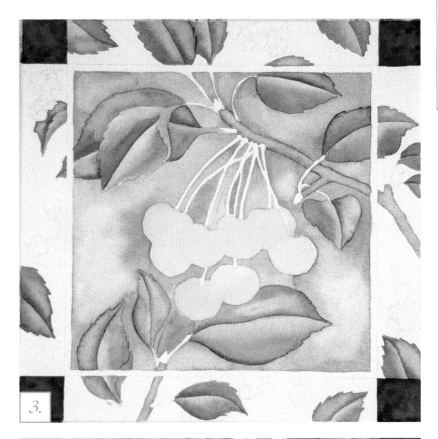

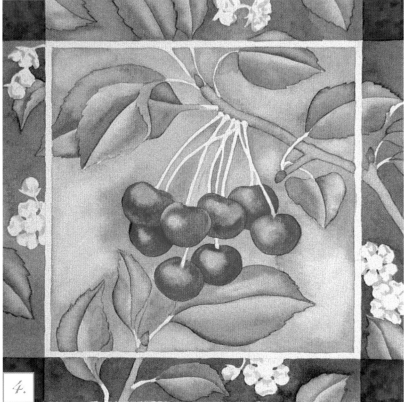

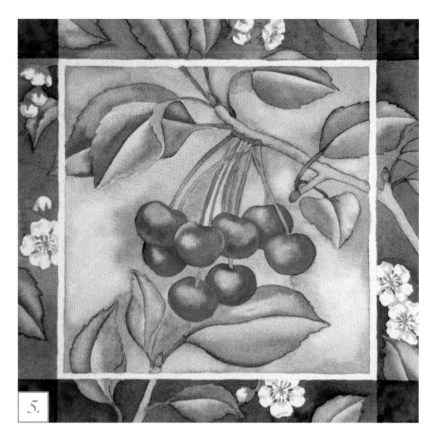

5. PAINT STEMS AND FLOWERS

Paint the stems and buds with a mixture of Indian or Venetian Red and Permanent Sap Green. Vary the mixture for the stems, and use slightly more Indian or Venetian Red for the buds. Paint the shadows on the flowers with a mixture of Cerulean Blue and Mauve. Paint the anthers with Cadmium Yellow Deep. Paint the stalks of the anthers with Permanent Sap Green.

6. ADD SHADOWS

Sketch shadows of the leaves and cherries in the center background and leaf shapes in the border. Paint the shadows with Payne's Gray. Paint around the leaf shapes in the background of the border with a mixture of Permanent Sap Green and Payne's Gray. Paint shadows on the cherries with a mixture of Mauve and Grumbacher or Winsor Red.

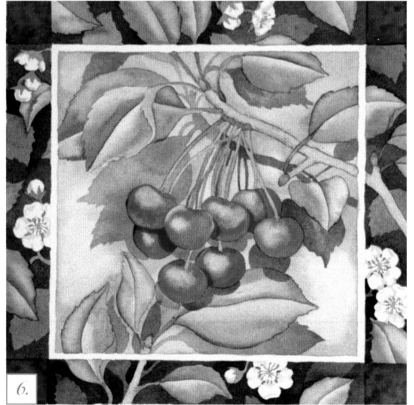

7. ADD DETAILS

Create texture on the branches by painting a series of short lines along the length of the branches with a mixture of Indian or Venetian Red and Payne's Gray. Add shadows to the branches with the same mixture. Add veins to the leaves with a mixture of Permanent Sap Green and Payne's Gray, beginning at the center vein and tapering toward the outer edge of the leaf. Position the painting so you can pull the stroke to the edge of the leaf. Add shadows on the flower stamens with a thin stroke of Yellow Ochre. Add shadows on the stalks of the anthers with thin strokes of Permanent Sap Green. Add shadows on the right sides of the cherry stems and leaf stems with a mixture of Permanent Sap Green and Indian or Venetian Red. Paint shadows on the leaves with a mixture of Permanent Sap Green and Payne's Gray. Paint the thin border with a mixture of Mauve and Indian Red. Allow the painting to dry, and then remove the drafting tape and erase any pencil lines.

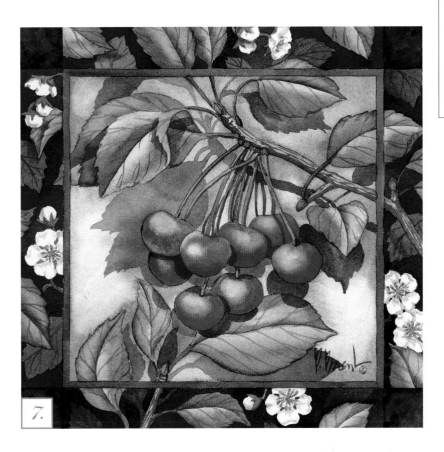

7.

Most people consider red and green a holiday color scheme. However, adding gray to the green, and yellow to the red, alters the hues enough to bring a new perspective to the colors and make them a favorite for every day. It's fun and exciting to work with color like this. Feel free to experiment with different combinations of colors and to rework old favorites in new ways.

Oriental Peonies

◆ *This painting of a stylized peony and a dragonfly has the quality of a delicate Chinese scroll painting.* The tone of the green background allows you to use the white gouache for both transparent and opaque washes. You could adapt this painting with an alternate color scheme for an entirely different feel.

MATERIALS LIST

BRUSHES
no. 3 round
no. 10 round
2-inch (51mm) flat

PALETTE
Payne's Gray
Permanent Sap Green

SURFACE
14" x 14" (36cm x 36cm)
 300-lb. (640gsm) cold-press
 watercolor paper

OTHER
black felt-tip pen
eraser
facial tissue
2H lead pencil
Winsor & Newton Permanent
 White Designer's Gouache

Painting Peony Petals

1.

2.

1. UNDERPAINT BLOSSOM

After the background wash has dried thoroughly, wash Permanent White gouache over the entire petal. While the area is still wet, apply more gouache to the tips of the petal, allowing it to bleed into the thinner wash. Allow the paint to dry.

2. PAINT VEINS

Create a very thick mixture of Permanent White gouache that will be opaque when dry. Paint thin veins, beginning at the base of the petal and letting the strokes taper as they approach the edge.

✦ DEMO ✦

Painting Peony Leaves

1. BEGIN LEAF

Paint around the outside edge of the upper leaf segment with a no.10 round brush and a mixture of Payne's Gray and Permanent Sap Green. Use the point of your brush to paint the jagged edges near the center of the leaf. Allow the area to dry.

2. FINISH UNDERPAINTING

Paint the lower half of the leaf with a no.3 round brush and a mixture of Payne's Gray and Permanent Sap Green. Apply a stroke down the center vein of the leaf and then create the varied points along the bottom edge of the leaf with a series of short, quick strokes. Allow the paint to dry.

3. ADD VEINS

Paint the veins with Payne's Gray. Pull the strokes from the center vein toward you, letting the strokes taper toward the outer edge of the leaf.

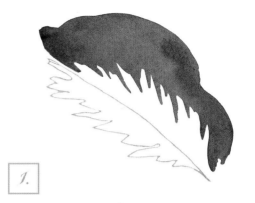

1.

2.

3.

Oriental Peony

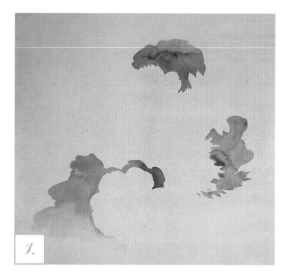

1. PAINT BACKGROUND

Make a generous mixture of a light value of Permanent Sap Green and Payne's Gray in a small plate or saucer. Evenly cover the surface of a sheet of watercolor paper with this mixture using a 2-inch (51mm) flat brush. Let it dry and then trace the drawing onto the toned paper. Paint the shadow areas of the background with a no. 3 round brush and a dark mixture of Payne's Gray and Permanent Sap Green, painting around the flowers and dragonfly. Use a very wet mixture and let the color flow within the painted area. Then let the paint dry.

2. PAINT GREENERY

Paint the stems and leaves with the same mixture. Vary the pressure on the brush as you paint the stems to vary the thickness of the lines. Paint the leaves with a no. 10 round brush. Give the leaves variety, too, making some strokes shorter and some longer. Also, vary their directions so they're not perfectly parallel.

3. BEGIN FLOWERS

Wash Permanent White gouache on the dragonfly's wings and buds with a no. 3 round brush. Load the brush with gouache and begin painting each petal at the tip. As you progress toward the base of each petal, thin the gouache and add water to your brush. The petals should look darker closer to the base of the flower as more of the background begins to show through. Leave a thin line of the background color between adjacent petals to define their shapes.

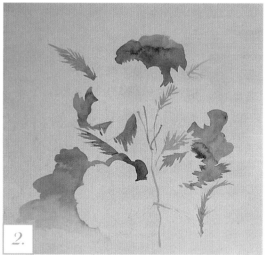

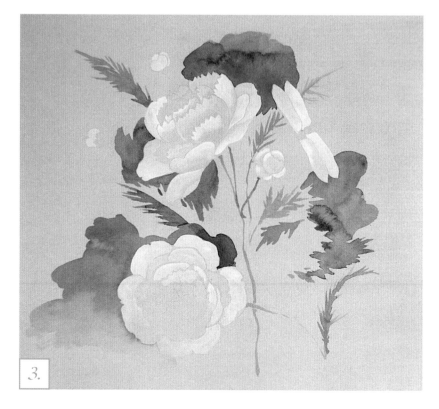

4. PAINT DRAGONFLY

Paint alternating segments of the dragonfly's body with Payne's Gray, and then stroke the center of each segment with a clean brush to lift color. Once these segments are dry, paint the remaining segments the same way. Paint the eyes with Permanent Sap Green, lifting color as you did from the body segments. Let one eye dry before painting the other. Paint veins on the leaves with Payne's Gray.

5. ADD LIGHT DETAILS

Add veins to the peony petals with Permanent White gouache. Position the painting so you can pull each stroke toward you, starting each stroke at the base of the petal and lifting the brush as you go so the veins taper toward the tips of the petals. Highlight the dragonfly wings and bodies with gouache.

6. ADD DARK DETAILS

Complete all the dark details with Payne's Gray: paint veins on the bud bases and leaves; add a shadow on the left side of the stem with a thin stroke; paint the dragonfly's feet and mouth and add a thin stroke around the wings. As you paint around the wings, vary your pressure on the brush to vary the thickness of the line. After the painting is dry, erase all pencil lines.

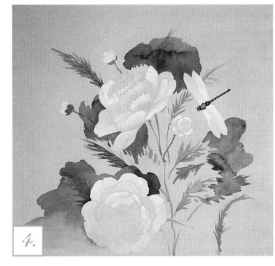

4.

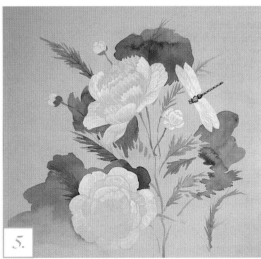

5.

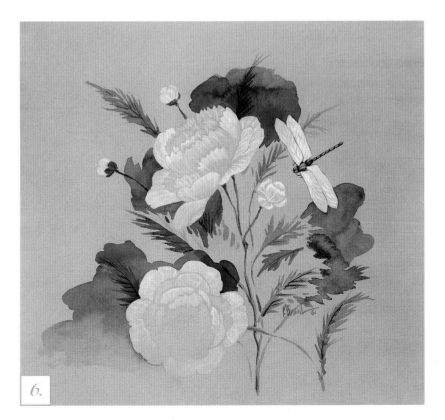

6.

You can change the background color of this painting to produce other beautiful paintings. I can envision this same subject on a blue, ochre or burnt umber background. Apple and cherry blossoms on this sort of background also would make beautiful subjects.

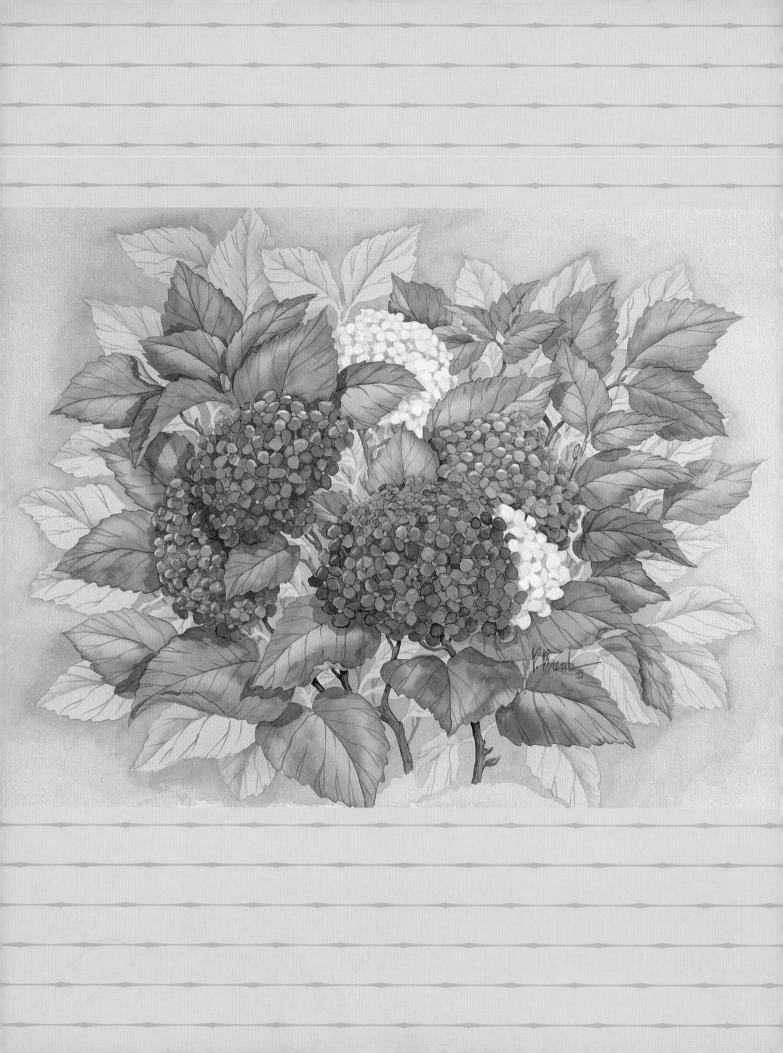

Antique Hydrangeas

✦ *Each hydrangea flower is made of many smaller blossoms whose rich color sits against heavy yellow-green leaves. This painting shows the three colors of hydrangeas—pink, blue and white— transforming them into subtle tones of purple, mauve and peach. Permanent White gouache highlights and a layered depth in the leaves and stems give dimension to this old-fashioned garden favorite.*

MATERIALS LIST

BRUSHES
no. 3 round
2-inch (51mm) flat

PALETTE
Cerulean Blue
Grumbacher or Winsor Red
Indian or Venetian Red
Mauve
Payne's Gray
Permanent Sap Green
Thalo or Winsor Crimson
Yellow Ochre

SURFACE
15" x 22" (38cm x 56cm)
300-lb. (640gsm) cold-press
watercolor paper

OTHER
black felt-tip pen
facial tissue
2H lead pencil
Winsor & Newton Permanent
White Designer's Gouache

Painting Pink Flowers

1. PAINT PETALS

After the background wash has dried thoroughly, paint non-adjoining petals of each pink flower with Thalo or Winsor Crimson. While each petal is still wet, clean your brush and lift some of the pigment from the center of each petal. Allow the paint to dry. Paint the rest of the petals in the same manner. Make sure each petal is dry before painting one next to it.

2. UNDERPAINT BACKGROUND

Paint the centers of the flowers with a value of Thalo or Winsor Crimson that is lighter than the petals. Paint around the flowers with a mixture of Thalo or Winsor Crimson and Mauve. Allow the paint to dry.

3. ADD ACCENTS TO BACKGROUND

Indicate background petal shapes between the flowers with random crescents and ovals, using a darker value of the Thalo or Winsor Crimson and Mauve mixture. Add shadows at the bottoms of the flower centers with a mixture of Thalo or Winsor Crimson and Mauve. Allow the paint to dry.

4. ADD FINISHING TOUCHES

Paint shadows where the petals overlap with a mixture of Thalo or Winsor Crimson and Mauve. Paint a line where each petal folds with the same mixture. Add highlights to the upper edges of the petals and the flower centers with Permanent White gouache.

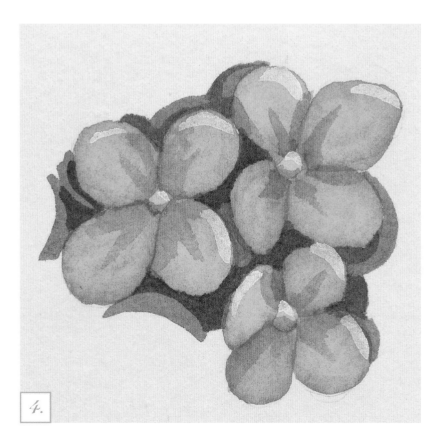

◆ DEMO ◆

Painting White Flowers

1. **PAINT PETALS**

After the background wash has dried thoroughly, paint non-adjoining petals of each white flower with a medium-value wash of Permanent White gouache. You don't need to lift any pigment. When these petals have dried, paint the remaining petals. The density of the gouache will vary, adding interest to the blossoms.

2. **UNDERPAINT BACKGROUND**

Paint the centers of the flowers with Permanent White gouache. Paint around the flowers with Yellow Ochre. Allow the paint to dry.

3. **ADD ACCENTS TO BACKGROUND**

Paint background petal shapes between the flowers with random crescents and ovals using Yellow Ochre. Add shadows at the bottoms of the flower centers with the same mixture. Allow the paint to dry.

4. **ADD FINISHING TOUCHES**

Paint shadows where the petals overlap and the line where each petal folds with Yellow Ochre. Add highlights to the upper edges of the petals and the flower centers with a heavy stroke of Permanent White gouache.

2.

1.

3.

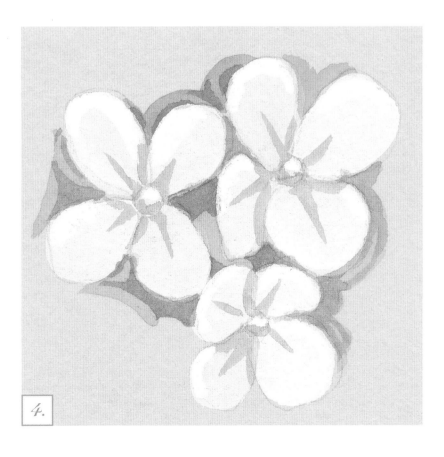

4.

Antique Hydrangeas

1.

2.

3.

1. BEGIN LEAVES

Brush an even wash of Yellow Ochre on an unwashed piece of watercolor paper with a 2-inch (51mm) flat brush. Allow the watercolor to dry and trace the drawing onto the toned surface. Using a no. 3 round brush, paint the upper half of each leaf with a mixture of Yellow Ochre and Permanent Sap Green. Vary the mixture so some of the leaves, especially the outer ones, are almost totally gold, others are mostly green and some are a mixture of the two colors. While each leaf segment is still wet, clean your brush and flood the center of the segment with clear water, allowing the watercolor to flow toward the edge of the leaf. Allow each leaf to dry before painting a leaf next to it.

2. FINISH UNDERPAINTING LEAVES

Paint the lower halves of the leaves and the turned edges the same way, this time flooding the clear water along the center vein instead of the center of the segment.

3. BEGIN PETALS

Paint petals that aren't touching each other first. Paint the purple petals with a mixture of Mauve and Thalo or Winsor Crimson, varying the amounts of red and purple from petal to petal. Paint the blue petals with mixtures of Cerulean Blue and Mauve. Paint the pink flower on the right with Thalo or Winsor Crimson, and the pink flower on the left with mixtures of Thalo or Winsor Crimson and Grumbacher or Winsor Red. Paint the white flowers with Permanent White gouache. While each petal is still wet, clean your brush and place a drop of clean water in the center.

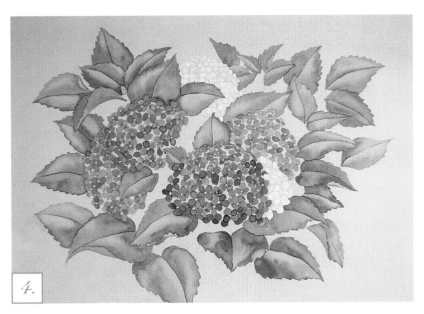

4. FINISH UNDERPAINTING PETALS

Allow the petals from Step 3 to dry and paint the rest of the petals the same way.

5. FILL IN FLOWER BACKGROUND

Paint the blossom centers with lighter values of the same colors as the petals. Then paint the spaces between the blossoms darker than the petals. Paint the spaces between the white flowers with Yellow Ochre. Paint the stems with a mixture of Permanent Sap Green and Indian or Venetian Red, using more green in the upper parts of the stems and more red in the lower parts.

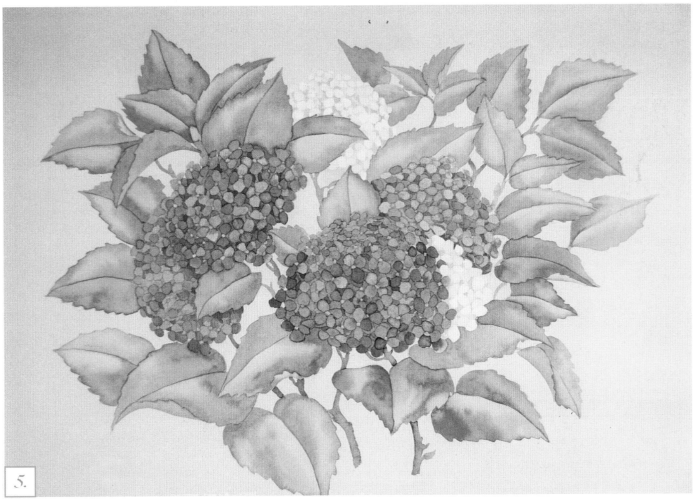

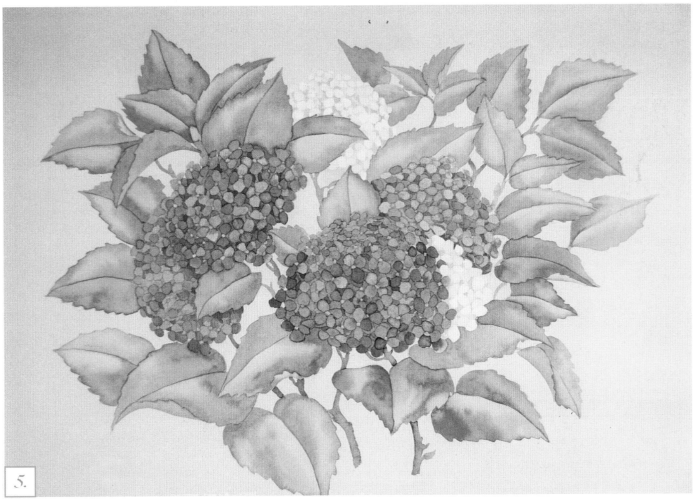

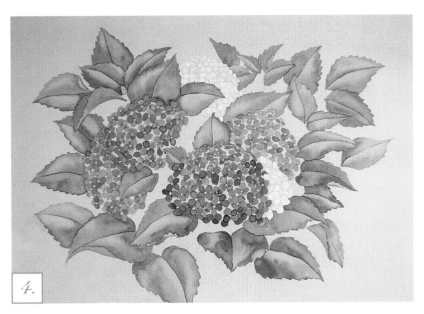

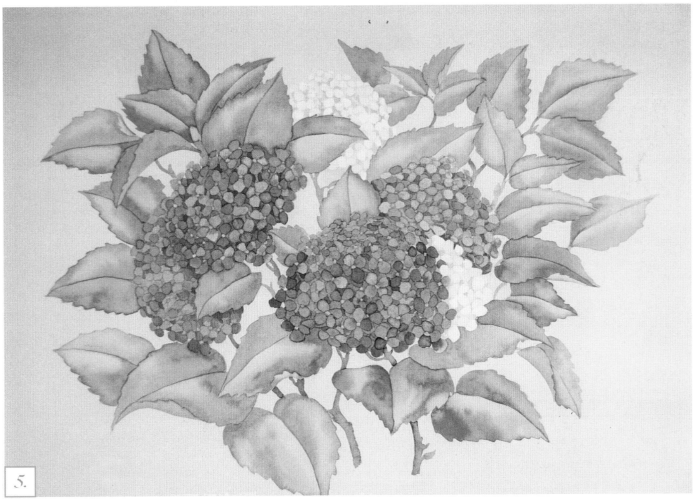

4.

5.

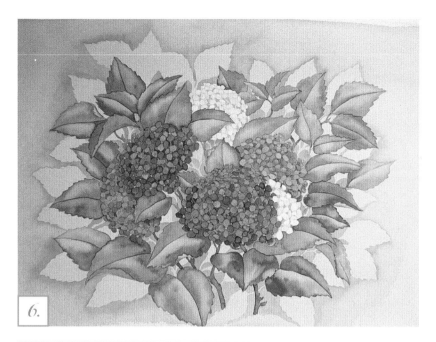

6.

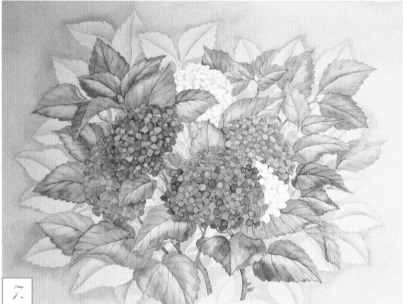

7.

6. BEGIN BACKGROUND LEAVES

Sketch the shapes of the background leaves and stems. Paint around these shapes with Yellow Ochre. Blend the dark outlines around the immediate edges of the leaves into the background with clear water.

7. ADD LEAF VEINS

Paint veins on the green leaves with a mixture of Permanent Sap Green and Yellow Ochre. Begin each stroke at the central vein and pull it to the edge of the leaf, letting the stroke taper toward the edge. Paint the center veins just above the center of each background leaf with Yellow Ochre. While the paint is still wet, clean your brush and blend the stroke toward the upper edge of the leaf. Blot the outer edge of the wet area with a tissue to prevent a hard line.

I'll admit that this subject takes a lot of patience. Varying the tiny blossoms on the flower while keeping the shape and shading consistent is a challenge. The result, however, is well worth the effort. The opaque white highlights, the shadows and the veins of the leaves add the final touches that bring this painting to life.

8. ADD DETAILS

Paint the rest of the veins on the background leaves with a mixture of Yellow Ochre and Permanent Sap Green. Add shadows on the green leaves with a mixture of Permanent Sap Green, Yellow Ochre and Payne's Gray. Paint shadows on the pink flowers with Mauve and on the white flowers with a mixture of Cerulean Blue and Mauve. Paint in random shadows to indicate petals overlapping petals within each group of blossoms, applying more shadows on the lower side of the group to indicate that the light source is shining from above.

9. ADD TEXTURE AND HIGHLIGHTS

Add a shadow to the lower edge of each flower stem with a mixture of Permanent Sap Green and Indian or Venetian Red. Add texture to the stems by painting short lines along the length of each stem with the same mixture. Add a stroke of Permanent White gouache to the upper edges of the petals near the top of each group of blossoms for highlights. Let the painting dry, and then erase your pencil lines.

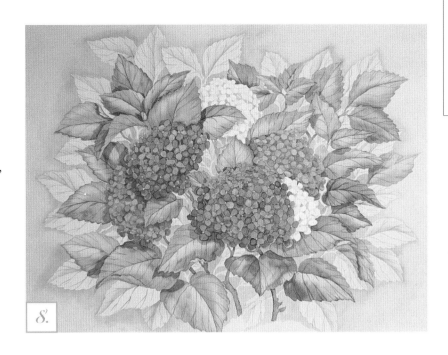

8.

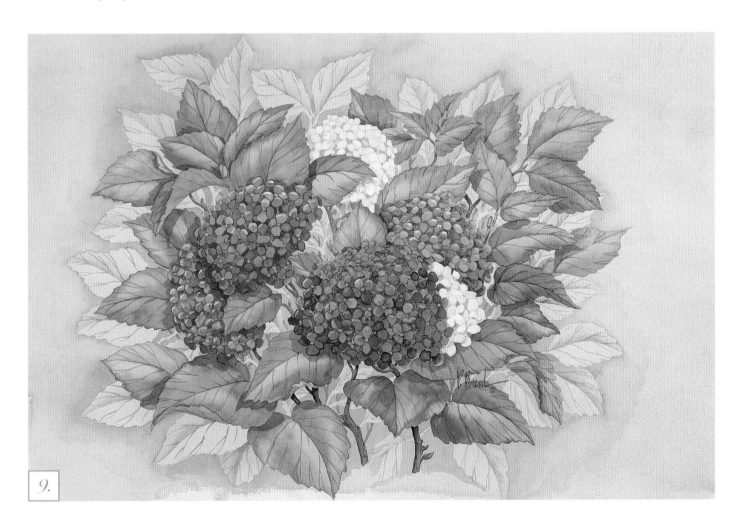

9.

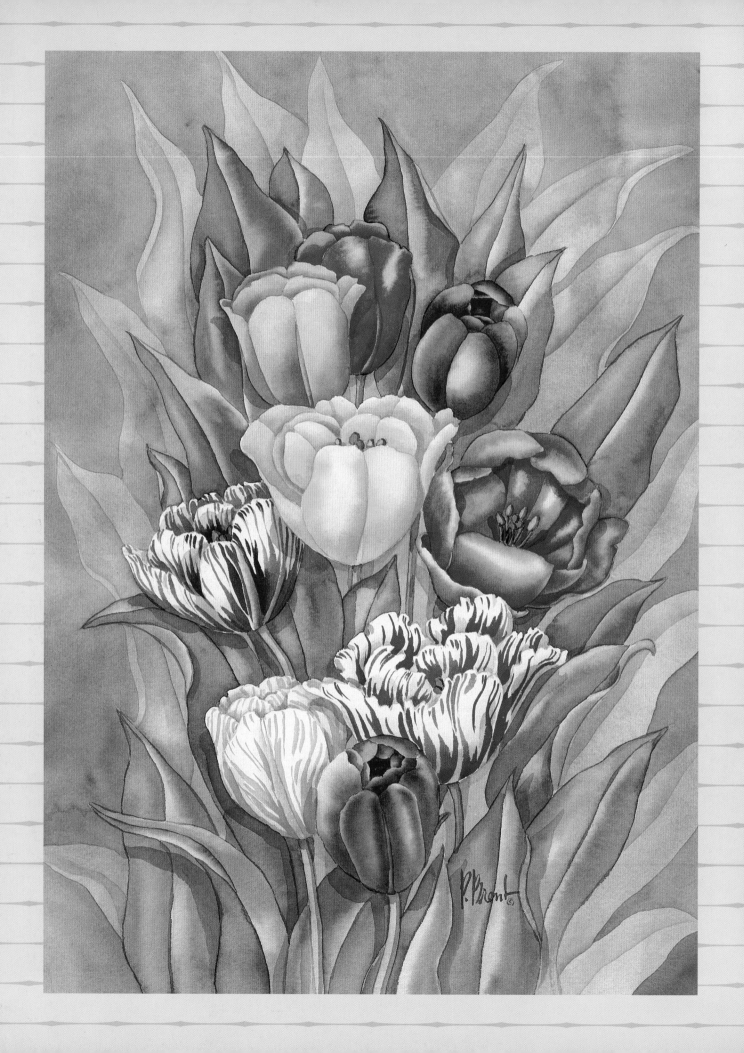

Spring Tulips

13

◆ *What splendid harbingers of spring are multicolored tulips! These flowers were so highly valued in the 1500s that fortunes were made and lost over the sale of a few bulbs. Today, tulips are still prized for their beauty and multitude of rich colors. This painting features both solid-colored and parrot tulips, which sport fringed petals with vivid stripes.*

MATERIALS LIST

BRUSH
no. 3 round

PALETTE
Cadmium Yellow Deep
Cerulean Blue
Grumbacher or Winsor Red
Indian or Venetian Red
Mauve
Payne's Gray
Permanent Sap Green
Thalo or Winsor Crimson
Ultramarine Blue
Vermilion

SURFACE
22" x 15" (56cm x 38cm)
 300-lb. (640gsm) cold-press
 watercolor paper

OTHER
black felt-tip pen
eraser
facial tissue
2H lead pencil

Painting Solid Tulip Petals

1.

2.

1. SHADE PETAL

Wet one half of the tulip petal with clear water. While the paint is still wet, paint a thin stroke of a mixture of Cerulean Blue and Mauve around the outer and lower edges. Use only a small amount of the mixture so the color stays close to the edge and doesn't bleed too far into the center. Allow this area to dry and paint the other half of the petal the same way. Allow this half to dry. Place a stroke of clear water over the center vein and a stroke of the same mixture along the right side of the vein.

2. ADD COLOR

Again wash half of the petal with clear water. Paint around the edges of the petal with a brush loaded with a lot of Thalo or Winsor Crimson, and allow the color to bleed almost into the center of the area. Clean your brush and blend the color to the center. You're trying to create a soft transition from very bright to very light. Allow the paint to dry.

3. FINISH PETAL

Paint the other half of the petal the same way. Allow the paint to dry, and then paint a stroke of Thalo or Winsor Crimson over the center vein. While the paint is still wet, clean your brush and lift some of the pigment from the vein.

3.

✦ DEMO ✦
Painting Parrot Tulip Petals

1. SHADE PETAL

Wet one half of the tulip petal with clear water. While the paint is still wet, paint a thin stroke of a mixture of Cerulean Blue and Mauve around the outer and lower edges. Use only a small amount of the mixture so the color remains close to the edge and doesn't bleed too far into the center. Allow this area to dry and paint the other half of the petal the same way. When the second half of the petal is dry, stroke a mixture of Cerulean Blue and Mauve over the center vein of the petal. While the paint is still wet, clean your brush and lift some of the pigment from the vein. Allow the paint to dry.

2. ADD COLOR

Load your brush with Mauve and begin each stroke at the base of the petal, pulling it toward you. Vary the thickness of the strokes by adjusting the pressure on the brush as you paint. Occasionally bring your brush entirely off the paper and set it back down again to create a broken line. Add more small lines at the top edge of the petal.

3. FINISH PETAL

Paint the second half of the petal the same way. Allow the paint to dry. Then paint the center vein with a stroke of Mauve, and while it's still wet, clean your brush and lift some of the pigment from the vein.

1.

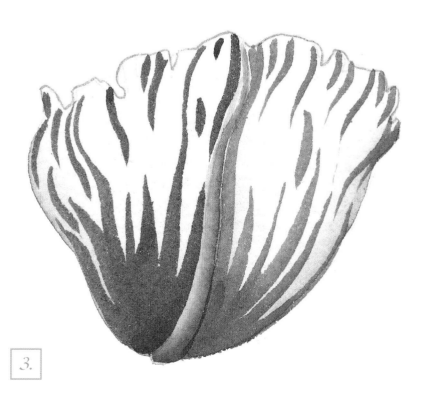

2.

3.

Spring Tulips

1.

2.

1. PAINT PETAL SHAPES

Trace the drawing of the tulips onto watercolor paper. Cover each petal with clear water. While the petal is wet, paint around the lower edges of each of the flower's outer petals with a mixture of Cerulean Blue and Mauve.

2. BEGIN LEAVES

Paint the left side of each leaf with a mixture of Permanent Sap Green and Cerulean Blue. While the leaf segment is still wet, clean your brush and stroke down the center of the segment to lighten the area. Allow the paint to dry before painting an adjacent area. Notice how the leaves already have helped define the shapes of the flowers.

3. FINISH LEAVES AND STEMS

Place a wide stroke of clear water along the right side of each leaf's center vein. While each area is still wet, paint the rest of the leaf with a mixture of Permanent Sap Green and Cerulean Blue, allowing the color to bleed into the clear water. Paint each stem with a mixture of Permanent Sap Green and Cerulean Blue. While the stem is still wet, clean your brush, gently dry it and stroke along the length of the stem to lighten it and make the stem appear round.

4. BEGIN BACKGROUND

Paint the background with Cerulean Blue. Work quickly and keep the area you're working on damp so the watercolor flows continuously. This will minimize dry lines. Allow the background to dry.

5. COMPLETE BACKGROUND

Sketch background leaf shapes surrounding the tulips and leaves. Apply a second wash of Cerulean Blue around the leaf shapes. Also, make sure to add a second wash of blue in a few areas between the leaves and stems to give depth. Define the individual tulip petals with pale washes of Cerulean Blue and Mauve, beginning your strokes at the points where two petals overlap. While the paint is still wet, clean your brush and blend the color toward the other edge of the petal. Blot the edge of the water with a tissue to prevent a hard edge from forming. Allow the painting to dry.

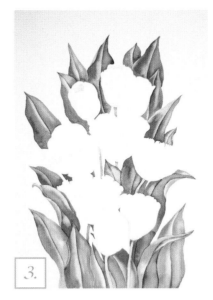

3.

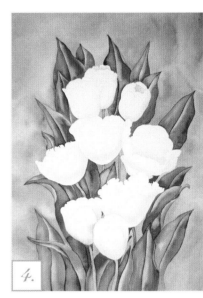

4.

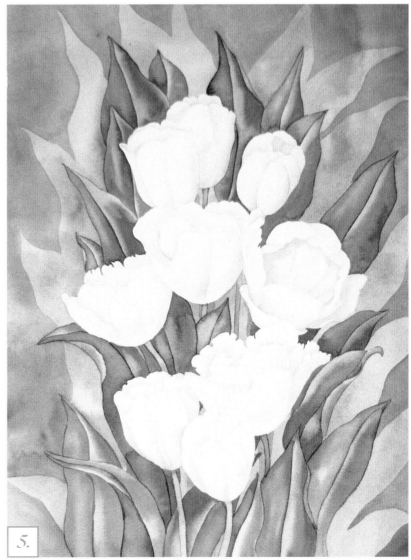

5.

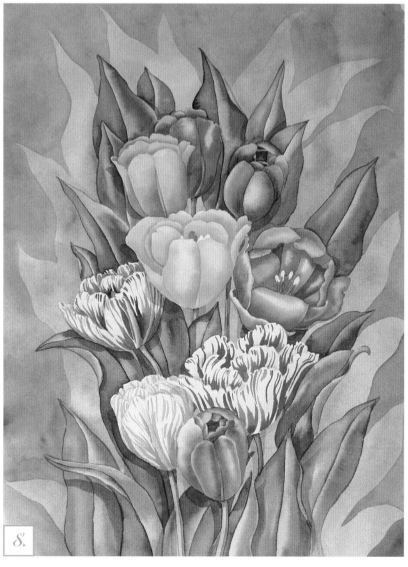

6. ADD COLOR TO PETALS

Add color on alternating petals so you're not painting an area before an adjacent area dries. Paint the purple tulips with Mauve, the bright pink tulip with Thalo or Winsor Crimson, the yellow tulips with Cadmium Yellow Deep, the red tulips with Grumbacher or Winsor Red and the orange tulip with a mixture of Cadmium Yellow Deep and Vermilion. To paint the solid-colored petals, wash the entire petal with clear water. Add color around the edges of the petal and allow the color to bleed toward the center as necessary to define the shape of the petal. To paint the striped tulips, begin each stroke at the base of the petal. As you move toward the tip of the petal, gently lift your brush so the stroke tapers. Allow the petals to dry.

7. FINISH SOLID PETALS

Continue painting the solid petals as you did in Step 6. After finishing each petal, stroke a thin line of that flower's color along the petal's vein and then lift some pigment with a clean, dry brush.

8. ADD SHADOWS

Lightly sketch shadows on the leaves, stems and petals. Paint the shadows on the greenery with a mixture of Permanent Sap Green and Payne's Gray. Paint the green parts of the tulip centers with a mixture of Permanent Sap Green and Cerulean Blue. Paint the shadows on the petals with a mixture of Cerulean Blue and Mauve.

9. ADD FINAL TOUCHES

Wash the left half of each background leaf with clear water. While this is still wet, paint a stroke of Cerulean Blue on the left side of the center vein, allowing the color to bleed into the clear water. Blot the edge of the water with a tissue to prevent a hard edge from forming. Paint the anthers, the brown parts of the tulip centers, with Indian or Venetian Red and allow them to dry. Paint the shadows on the anthers with a darker value of Indian or Venetian Red. Paint the shadows on the green parts of the tulip centers with a mixture of Permanent Sap Green and Payne's Gray. Allow the painting to dry and erase all pencil lines.

Don't be afraid to make a painting your own. Experiment with a monochromatic color scheme for the tulips, or change the background color. You could also give this subject an "antique" look by laying down a wash of Yellow Ochre before painting the tulips.

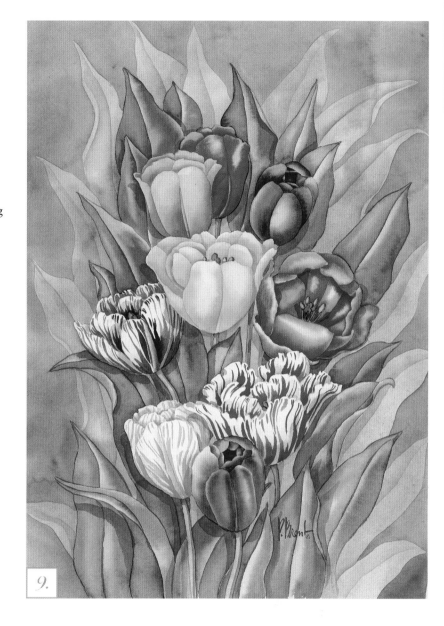

9.

Conclusion

I hope you've enjoyed this book and gained a greater knowledge of watercolor techniques. For the beginner, this book has been about controlling watercolors. The intermediate artist should have gained insight into color use and creation of forms. For the advanced artist, I hope that you've been able to add another dimension to your collection of skills and that you now can incorporate these techniques into your own personal style.

Watercolor is a medium that is so varied and can accommodate such a wide range of creative expression that it's impossible to cover all the possibilities in one book. Here I've focused on the materials and techniques that create a certain illusion of reality, but this illusion can look no better than the drawing and composition the artist creates before the first stroke of paint. Success in any and all aspects of painting comes from observation and repetition, but you'll see results after even a few practice sessions with the techniques from this book. Keep at it!

Index

Index *continued*

Explore your artistic side with these other fine North Light Books!

Sharon Buononato, CDA, shows you how to paint landscapes that evoke feelings of nostalgia, hearth and home. Inside you'll find 6 easy-to-follow projects, including start-to-finish instructions, detailed drawings, traceable patterns, helpful hints and invaluable advice for painting trees, flowers, water, skies, birds, barns, mills, stonework and more!

ISBN 1-58180-160-2, paperback, 144 pages, #31909-K

Beautifully illustrated and superbly written, this wonderful guide is perfect for watercolorists of all skill levels! Gordon MacKenzie distills over thirty years of teaching experience into dozens of painting tricks and techniques that cover everything from key concepts, such as composition, color and value, to fine details, including washes, masking and more.

ISBN 0-89134-946-4, hardcover, 144 pages, #31443-K

This guide makes using color simple. Best of all, it's as fun as it is instructional, featuring ten step-by-step projects that illustrate color principles in action. As you paint your favorite subjects, you'll learn how to make color work for you. No second-guessing, no regrets-just great-looking paintings and a whole lot of pleasure.

ISBN 1-58180-048-7, paperback, 128 pages, #31796

Packed with insights, tips and advice, Watercolor Wisdom is a virtual master class in watercolor painting. Jo Taylor illustrates every important technique with examples, sketches and demonstrations, covering everything from brush selection and composition to color mixing and light. You'll learn how to find your personal style, work emotion into your work, understand and create abstract art and more.

ISBN 1-58180-240-4, hardcover, 176 pages, #32018-K